FOSSIL RIDGE PUBLIC LIBRARY DISTRICT

P9-CRI-821

Fossil Ridge Public Library District
25452 Kennedy Road
Braidwood, Illinois 60408

GAYLORD

MATHEW BRADY
His Life and Photographs

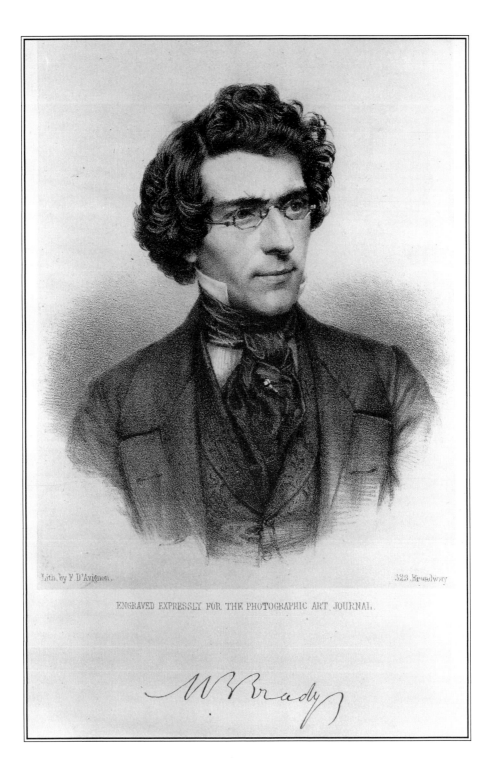

Lith. by F. D'Avignon.

323 Broadway.

ENGRAVED EXPRESSLY FOR THE PHOTOGRAPHIC ART JOURNAL.

FOSSIL RIDGE PUBLIC LIBRARY DISTRICT
Braidwood, IL 60408

Mathew Brady

His Life and Photographs

George Sullivan

ILLUSTRATED WITH PHOTOGRAPHS

COBBLEHILL BOOKS
Dutton New York

Frontispiece: This portrait of Mathew Brady appeared in the
Photographic Art Journal in 1851. He was twenty-seven or twenty-
eight at the time.

PHOTOGRAPH CREDITS

Alberti/Lowe Collection, 8, 75, 104, 123; Howard C. Daitz/Photographica, 34, 35;
Library of Congress, *ii*, 3, 11, 26, 28, 29, 39, 42, 61, 63, 65, 67 (top), 68, 69, 70,
71, 74, 78, 80, 88–89, 90, 99, 101, 108, 111, 113, 118; National Archives, 97,
102, 110; National Portrait Gallery, Smithsonian Institution, 23, 47, 55, 57, 94;
New York Historical Society, 13, 21, 52; New York Public Library, 10, 16, 67
(bottom); Lloyd Ostendorf Collection, 4, 19, 86; Sotheby's, Inc., 54; George
Sullivan, 43, 49, 125; George Sullivan Collection, 120–121;
Swann Galleries, Inc., 77.

Copyright © 1994 by George Sullivan
All rights reserved
No part of this book may be reproduced in any form
without permission in writing from the Publisher.

Library of Congress Cataloging-in-Publication Data
Sullivan, George, date
Mathew Brady : his life and photographs / George Sullivan.
p. cm.
Includes bibliographical references and index.
ISBN 0-525-65186-1
1. Brady, Mathew B., 1823 (ca.)–1896—Juvenile literature.
2. Photographers—United States—Biography—Juvenile literature.
3. Portrait photography—United States—History—Juvenile
literature. 4. United States—History—Civil War, 1861–1865—
Photography—Juvenile literature. [1. Brady, Mathew B., 1823 (ca.)–1896.
2. Photographers. 3. United States—History—Civil War, 1861–1865.]
I. Title. TR140.B7S85 1994 770'.92—dc20 [B]
93-28354 CIP AC

Published in the United States by Cobblehill Books,
an affiliate of Dutton Children's Books,
a division of Penguin Books USA Inc.
375 Hudson Street, New York, New York 10014

Designed by Mina Greenstein
Printed in the United States of America
First Edition 10 9 8 7 6 5 4 3 2 1

AUTHOR'S NOTE

THIS WAS a particularly difficult book to write because so much of the available source material proved to be unreliable. Accounts of interesting incidents were often found to be untrue. Photographs frequently attributed to Brady were discovered to have been taken by other photographers. It was something like walking through a minefield. In addition, there were long periods of Brady's life for which scarcely any information was available at all. Even his date of birth was in question.

In attempting to separate fact from fiction, the works of Josephine Cobb, William A. Frassanito, and Dorothy Meserve Kunhardt and Philip B. Kunhardt, Jr., were very useful. I am also grateful to many individuals who helped me by suggesting sources of information, vetting portions of the manuscript, and providing photographs and reproductions of engravings. Special thanks are due the following: Ann Shumard, National Portrait Gallery, Smithsonian Institution; William Stapp, International Museum of Photography, George Eastman House; Maja Keech, Library of Congress; Denise Bethel, Sotheby's; Daile Kaplan, Swann Galleries; Dale Neighbors, New York Historical Society; Roz Ryan, Future Phase Computer Systems; Francesca Kurti, TLC Labs; Howard Daitz, Ron Lonergan, Sal Alberti, James Lowe, and Lloyd Ostendorf.

CONTENTS

Introduction

In October, 1862, just days after what had been the bloodiest single day of fighting in the Civil War, Mathew Brady presented an exhibition of photographs at his elegant gallery in New York City that fascinated and shocked visitors. Nothing like them had ever been seen before. Titled "The Dead at Antietam," the photographs depicted roads, fields, and peach orchards where young Americans lay stiff, their arms outstretched, their lifeless bodies swollen and twisted.

In reviewing the startling photographs, the *New York Times* said: "Mr. Mathew Brady has done something to bring us the terrible reality and earnestness of the war. If he has not brought bodies and laid them in our dooryards and along our streets, he has done something very like it." Other articles describing the "terrible reality" of the Antietam photographs appeared in such popular magazines of the day as *Harper's Weekly* and the *Atlantic Monthly*.

Mathew Brady did not take the photographs at Antietam. They were the work of Alexander Gardner and James F. Gibson, photographers who worked for Brady at the time.

But it was he who understood their drama and power. Brady was among the first to realize that a photograph was something more than an object to be pasted in an album or displayed on a bookcase. He also understood the value photographs could have in helping the public to appreciate and understand recent events.

Photography, introduced in 1839, was a fairly new medium in the 1860s. It had been used almost exclusively for making portraits, for recording people's likenesses. Part of the shock of seeing the pictures of Antietam's battlefield dead was that no one had ever seen such powerful images before.

"Renowned Photographer of the Civil War" are the words etched on Mathew Brady's tombstone at the Congressional Cemetery in Washington, D.C. And it is as a Civil War photographer that Brady is usually remembered. The truth is that Brady, with only a handful of exceptions, did not go out into the Civil War battlefields and take photographs himself. Even if he wanted to, his poor eyesight probably would have prevented him from doing so.

When the Civil War erupted in 1861, Brady set a goal of recording all of the "prominent incidents of the conflict." Brady "would serve history and country," wrote Carl Sandburg in *The Photographs of Abraham Lincoln*. "He would prove what photography could do by telling what neither the tongues nor the letters of soldiers could tell of troops in camp, on the march, or mute and bullet-riddled on the ground."

When the war grew far beyond the ability of Brady or any one person to cover it, Brady organized teams of photographers and sent them out

Photographs such as this one, depicting Confederate dead gathered for burial after the Battle of Antietam during the Civil War, shocked Americans of the 1860s. Taken by Alexander Gardner, the photograph was published by Brady & Co.

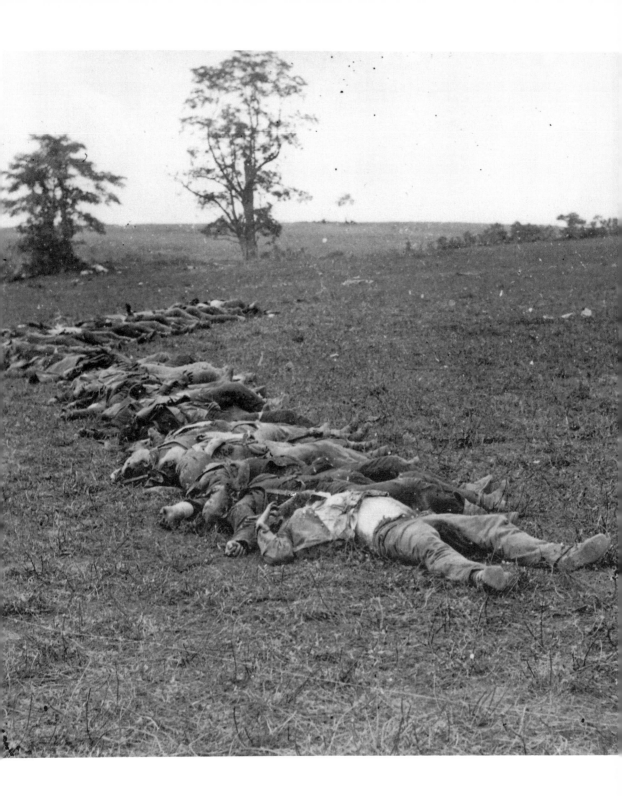

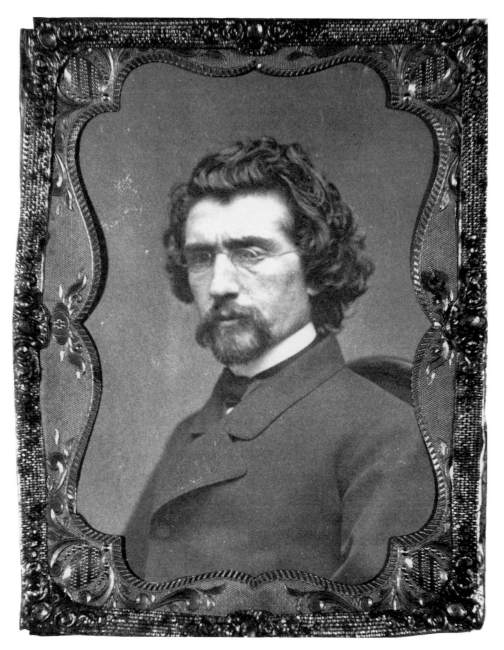

Mathew Brady was in his early thirties when this photograph was taken around 1856.

with Union forces. Mathew Brady was a manager of photographers during the Civil War. He financed them; he supervised them. Today, because of Mathew Brady more than anyone else, the nation has a full and rich pictorial history of the war.

Long before the Civil War began, Mathew Brady had achieved widespread fame. "Brady of Broadway" he was called. He and his studio cameramen photographed virtually every notable American of the time —presidents, their cabinets, and their aides, actors and writers, physicians and lawyers, prominent women, military leaders, and members of the clergy. His portraits were featured in his warmly praised collection, *The Gallery of Illustrious Americans*.

Not only was Brady well known for his portraits of the rich and famous, but also for his fashionable galleries in New York and Washington, like few others in the world, and for the medals and other prizes he had won in the United States and abroad for his photographic excellence.

The Civil War itself, the event for which he is usually remembered, helped to trigger Brady's financial ruin. The huge amounts he spent for war photographs helped to plunge him into debt. When he died in 1896, he was poverty-stricken and virtually forgotten. The tributes to him for his contributions to American culture came from later generations.

There were photographers of the nineteenth century who were more creative than Mathew Brady. There were others who pioneered technical advances in the photographic art.

But Mathew Brady did more. In photography's early days, he was the first to understand the significance of photographs and how they could be used to provide a visual record of people and events. Pictures could serve as the nation's memory, he realized.

No wonder Mathew Brady has been called "the first of the photographists," "Mr. Lincoln's Camera Man," and, during the nineteenth century, "the greatest historian on the American scene." This is the story of his life and vision.

1

The Early Years

How old are you?" an interviewer from the *New York World* once asked Mathew Brady who, in the article that resulted, was described as "The Grand Old Man of American Photography."

"Never ask that of a lady or a photographer; they are sensitive," Brady replied. "I will tell you, for fear you might find out, that I go back to 1823–24."

Brady also recalled for the interviewer that his place of birth was "Warren County, New York, in the woods around Lake George."

Outside of these facts, very little is known about Mathew Brady's birth or boyhood. He wrote no autobiography. He kept no diary. There are scarcely any articles available in which Brady contributed information about his life and work. The only major interview with Brady, the in-

terview with the *New York World* that is quoted above, took place in 1891, when he was almost seventy years old.

Information about Brady is so scarce that even the spelling of his first name has been questioned. Matthew is normally spelled with two *t*'s. Brady is believed to have spelled it with only one.

Brady almost always signed his name "M. B. Brady," which doesn't settle the matter. But, according to William Stapp, the Senior Curator of Photography at the International Museum of Photography at George Eastman House, a few documents exist in which Brady signed his name in full, and he signed it "Mathew."

But Brady seldom wrote anything during his lifetime. Most letters he dictated. Putting words on paper seems to have been an uncomfortable experience for him, for his handwriting is forced and clumsy.

Brady once noted that his father "was an Irishman." His father and mother were, in fact, Irish immigrants. They arrived in America in the early 1820s.

Mathew was the youngest of five children. While no copy of his birth certificate is known to exist, it is generally believed that he was born in 1823. The Library of Congress accepts 1823 as his date of birth. In addition, James Horan, a biographer of Brady's, noted that the year 1823 was listed as the date of his birth on Brady's death certificate. And 1823 also "tallies with the census records and other documents I was able to find," says Will Stapp.

The Brady family farmed for a living in Warren County on the eastern slope of the Adirondack Mountains in upstate New York. "They settled in an extremely poor area of upstate New York," says Will Stapp, "poor for farming, that is."

Mathew, as a young boy, must have helped out on the farm. He might have continued as a farmer but during his mid-teens, his life took an abrupt turn. He had always suffered from what he once described as

Brady signed his name "M. B. Brady," and that's how it appeared on his business card.

"inflammation of the eyes," a disease that weakened his eyesight. In search of a cure, his parents are believed to have sent him to the nearby resort of Saratoga Springs. Remarkable health benefits had been credited to the natural spring waters there.

While at Saratoga Springs, Mathew met a twenty-eight-year-old painter named William Page, who had his studio in Albany. The two became friends. "He took an interest in me," Brady once recalled, "and gave me a bundle of his crayons to copy." (By crayons, Brady meant crayon drawings.) Later, Brady may have helped Page around his studio, performing such chores as washing brushes, preparing paints, and stretching canvases.

Earlier, Page had studied painting at the National Academy of Design in New York City. Samuel F. B. Morse, the artist and inventor, and also the first president of the Academy, was one of Page's teachers.

In 1839, Page decided to return to New York and Brady went with him. New York was a bustling and fast-growing city at the time, one of noise, excitement, and opportunity. Its 300,000 people were mostly

clustered in the lower half of Manhattan, surrounded on three sides by docked sailing ships. Immigrants had begun to flood into the city from England, Scotland, Ireland, Germany, and other northern and western European countries. The streets were filled with horse-drawn carts and carriages, with hurrying tradesmen and businessmen, and women in long, full skirts.

Mathew got a job as a clerk at A. T. Stewart's department store, located at Chambers Street and Broadway. He probably lived in one of the city's many boardinghouses. By 1843, he was listed in a New York business directory as a manufacturer of jewelry cases.

William Page, meanwhile, set up a studio and continued to paint portraits. Undoubtedly, one of the first things Page did was look up his old friend, Samuel F. B. Morse. Brady is likely to have gone along and been introduced to Morse.

At the time, the forty-eight-year-old Morse was seeking financing for the telegraph, the device that enabled messages in coded signals to be sent by electricity. The telegraph was to revolutionize the world of communications.

At the same time, Morse was experimenting with the camera. He had become one of the first Americans, if not *the* first, to actually take a picture. Morse and his work were to have an important influence upon young Mathew Brady.

WHEN MATHEW BRADY was born, there was no photography. It had not been invented.

But the optical principle on which photography was to be based had been known for centuries. The ancient Greek philosopher Aristotle noted that light passing through a small hole in the wall of a room formed an image of any object or scene in front of the hole on the wall opposite it.

In Italy in the 1500s, this principle was used to build what was called

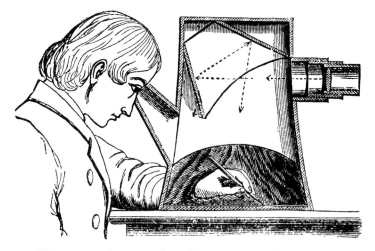

The camera obscura *reflected images onto a viewing screen.
The images could then be easily traced.*

a *camera obscura*, a darkened chamber. It took the form of a large box with a lens in one side and an eyepiece at the side opposite. Objects upon which the lens was focused were reflected by a mirror system onto a viewing screen at the bottom of the box.

Artists used the *camera obscura* as a sketching tool. Images reflected onto the screen could be viewed through the eyepiece and, with the addition of a lighttight opening for the artist's hand, could be easily traced.

As this suggests, the optical principle upon which photography was to be based was well known. The chemical process necessary to capture and retain the projected image was a mystery. Remove the object from in front of the *camera obscura's* lens and the image disappeared. The *camera obscura* had no memory.

The problem was solved by a French inventor named Joseph Nicép-hore Niepce. In 1826, Niepce coated a sheet of pewter with a light sensitive chemical. He then placed the plate in a camera opposite the lens and pointed the lens through a window to a brightly lighted scene that included a tree, a chimney, a rooftop, and part of a house. After

Louis J. M. Daguerre, inventor of the daguerreotype. This is a copy of a lithograph made from a daguerreotype taken in 1848.

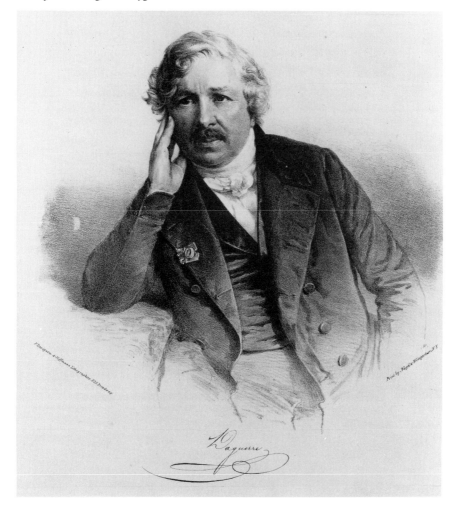

eight hours, Niepce removed the plate and washed it with a mixture of oil of lavender and oil of white petroleum. What remained on the plate was a permanent image of the scene outside the window.

Louis J. M. Daguerre, a French stage designer and painter, took Niepce's photographic process a step further in 1837. Daguerre treated a thin sheet of silver-plated copper with fumes from heated crystals of iodine. This made the silvery plate sensitive to light.

Daguerre then placed the plate in a boxlike camera and exposed it through the camera lens for from five to forty minutes (instead of eight hours, as the Niepce process required). After the plate was removed from the camera, it was developed with vapors from heated mercury.

The result was a richly detailed black-and-white image on a mirrored surface. The final step was to "fix" the image—make it permanent—by treating the plate with sodium thiosulfate. Such images came to be known as "daguerreotypes."

After a description of the process was published in 1839, improvements quickly followed. By 1841, the exposure time for pictures had been cut to less than a minute.

Samuel F. B. Morse had visited Paris some months before the announcement of Daguerre's invention. Morse had gone to France with the hope of interesting the French government in his telegraph.

Morse, as an artist, was thoroughly familiar with the *camera obscura*. As a teenager at Yale, Morse had even experimented with fixing images produced by the device. He was thrilled to learn that Daguerre had succeeded where he had failed.

Morse's idea was to use the daguerreotype process to simplify his work as a portrait painter. Instead of having a person pose for long

An advertisement placed by Brady in Rode's New York City Directory *for 1850–51, four years after he opened his first studio.*

BRADY'S
NATIONAL GALLERY
OF
DAGUERREOTYPES.

This collection embraces some of the most distinguished men of this country The President and Cabinet, also the late President Polk and his Cabinet, Members of the United States Senate and House of Representatives, Judges of the Supreme Court at Washington, and many other eminent persons are included in this Gallery. The Proprietor being much of his time in Washington has the advantage of adding to these portraits any others that may interest the public. This establishment is one of the most extensive in the world, its facilities for producing portraits by the Daguerrean art being unrivalled. It now occupies two large Buildings, 205 and 207 BROADWAY. The operating department is arranged in the most scientific manner, and directed by persons of acknowledged skill in the profession. In the department arranged for copying paintings, daguerreotypes, engravings, statuary, &c., the light and instruments have been expressly designed for this purpose. It is the aim of the proprietor to render in every part of his business that attention which the public are entitled to from the patronage he has received. At the annual exhibitions of the American Institute for five years, the pictures from this establishment received the first prize, consisting of a silver medal. The last year, the first gold medal ever awarded to Daguerreotypes was bestowed on the pictures from this Gallery. The portraits taken for the "Gallery of Illustrious Americans," a work so favorably received throughout the United States, are engraved from these Daguerreotypes. Strangers and Citizens will be interested and pleased by devoting an hour to the inspection of Brady's National Galery,

205 & 207 Broadway, cor. Fulton St., N. Y.

periods, he thought of making a daguerreotype of the subject, and then copying it.

When he returned to New York, Morse set up a studio in a building owned by his brother at the corner of Nassau and Beekman streets. By the fall of 1839, he was able to take his own pictures. "My first effort," Morse said in a letter to a friend, "was on a small plate of silvered copper procured at a hardware store, and, defective as the plate was, I obtained a good representation of the Church of the Messiah, then on Broadway, from a back window of the New York City University."

Morse and other early American daguerreotypists were aided by François Gourand, a pupil of Daguerre's who arrived in New York late in 1839. He demonstrated Daguerre's photographic process and sold cameras and instruction manuals.

It is likely that Brady attended public lectures on the art of the daguerreotype process given by Gourand. He also began selling cases he made to New York daguerreotypists, who used them for mounting portraits. Brady undoubtedly learned from these customers, too.

Bit by bit, Brady began to become skilled in the new art of photography. He had little knowledge of chemistry, and this no doubt slowed his progress. He was also hindered by his poor eyesight. But Brady was filled with energy and eager to succeed. In 1844, at the age of twenty-one, Brady opened a gallery on the fourth floor of a building at 205 Broadway in New York and began making daguerreotypes. He called it Brady's Daguerrian Miniature Gallery. He had the name painted across the front of the building above the windows.

In the building's street-level windows on either side of the entrance, Brady displayed examples of his work. Painted on the wall inside the entrance was a forefinger pointing up the stairway and a sign that read THREE FLIGHTS UP. After making the climb, a customer was likely to be greeted by young Brady himself.

2

"Don't Move a Muscle!"

I n 1888, George Eastman, an American inventor and industrialist, introduced the Kodak box camera. Inexpensive, light in weight, and easy to operate, it enabled most people, even nonprofessionals, to take good pictures. It was a forerunner of today's point-and-shoot cameras, with their ability to capture fast action.

Inside the camera was a roll of film that could record up to one hundred black-and-white photographs. After the roll had been used, the camera owner sent the camera with the film inside to one of Eastman's processing plants. The plant developed the film, made the prints, and returned them. The company also sent back the camera loaded with new film.

"You Press the Button, We Do the Rest" was Kodak's slogan in those days.

The box camera and the easy processing represented a giant step

DAGUERREOTYPES.

Brady, M. B.

FIRST PREMIUM NEW-YORK DAGUERRIAN MINIATURE GALLERY,

Corner of Broadway and Fulton-street,

Entrance third door from Broadway,

Where may be had Miniatures which for beauty of *coloring, tone* and *effect*, cannot be surpassed. By a new process, the dim and shadowy appearance of the pictures formerly so much complained of, is entirely obviated; and Mr. Brady respectfully invites the criticism of a just and intelligent public.

Likenesses in all cases warranted to give satisfaction, and colored in the most beautiful manner by a practical and competent artist.

Ladies, Gentlemen, and all strangers are invited to call at the Gallery, whether they intend sitting or not.

Miniatures taken in all kinds of weather, from 8 A. M. till 5 P. M.

☞ The AMERICAN INSTITUTE awarded a first premium to Mr. Brady at the late Fair.

Instructions carefully given in the art.

M. B. BRADY.

Brady invited "Ladies, gentlemen, and all strangers" to call at his gallery.

forward. Before George Eastman, photography was tied to the studio or workroom and was the domain of a limited number of professionals and amateurs. The word "snapshot," to describe a photograph taken quickly with a small, hand-held camera, hadn't been invented.

The camera of the 1840s and 1850s was too big to be held by hand. A tripod or other support was needed to keep it perfectly still for the time of the exposure, which was at least as long as fifteen seconds.

And the chemicals and equipment needed for processing the exposed plate, the flat, polished metal surface on which the image was to appear, had to be close at hand. Without a workroom a few steps away from the camera, no photography was possible.

Mathew Brady's first studio at 205 Broadway was a three-story building to which Brady had a fourth floor added, which permitted him to install skylights. Using these was an innovation of Brady's that increased the light level in the studio and helped to eliminate the unsightly shadows that sometimes spoiled early daguerreotypes.

Most of the daguerreotypes taken at the studio were family portraits. Children posed frequently. The studio operated from eight o'clock in the morning until six in the evening, depending on the availability of natural light.

Brady's gallery included a changing room where the subject put on clothes that were suitable for picture taking. Dark jackets and dresses were preferred. Anything white or very light exposed much faster than clothing with colors and became too conspicuous in the final photograph.

The subject took a seat in front of the camera which was mounted on a tripod. Lighting was adjusted so there were no shadowy portions on the face.

To aid subjects in keeping their heads still during the exposure, photographers relied on a device called the *immobilizer*. It consisted of a clamp that fitted to the back of the sitter's head and was connected to a heavy metal rod that locked into the floor. Since the clamp was behind

the sitter's head and the rod behind the sitter's body, they could not be seen in the photograph.

The plate upon which the sitter's image was to be recorded was prepared in advance. A sheet of copper that had previously been coated with silver and buffed was washed in a solution of nitric acid to make it absolutely clean. Then it was treated with iodine vapor (the fumes of which filled the gallery), which made it sensitive to light.

When all was in readiness and the camera focused, the plate was inserted in the back of the camera. "Don't move a muscle!" the sitter was told. "Don't even breathe!"

The operator then removed the cap from the camera's lens. The subject strained to remain as still as a statue. No one even spoke. After the required exposure time, the lens cap was replaced and everyone breathed a sigh of relief.

The plate was removed from the camera, then developed and mounted. At some studios, the process was completed in fifteen minutes to half an hour.

Brady charged from two to five dollars for a daguerreotype portrait, depending on its size. Most other studios charged less.

In the early years of his studio's operation, Brady worked hard to master the techniques of photography, but later he left the actual photographic work to a camera operator. Other assistants prepared the plates and did the developing, tinting, and mounting.

It's much different today, of course, when photography is often looked upon as a creative art. Those who enjoy pictures by such noted twentieth-century photographers as Edward Weston or Paul Strand expect that Weston or Strand actually took the images for which they are credited. It was different in the 1840s and 1850s. Teamwork was required to produce a photograph. The operator, the individual who actually removed the lens cap to take the picture, was merely one member of the team.

Brady's role was similar to that of a modern-day cinematographer on a major motion picture. It's the cinematographer who supervises the camera crew and is responsible for a wide range of other matters—the kinds of cameras and sizes of lenses to be used, the placement of the cameras, the exposure values to be used, and the lighting.

Brady, besides supervising the taking of the photograph, also lent a hand in posing the subjects. Many of the people who visited Brady's

Like all portrait subjects of the time, Lincoln had to wear a head clamp when he posed for Brady.

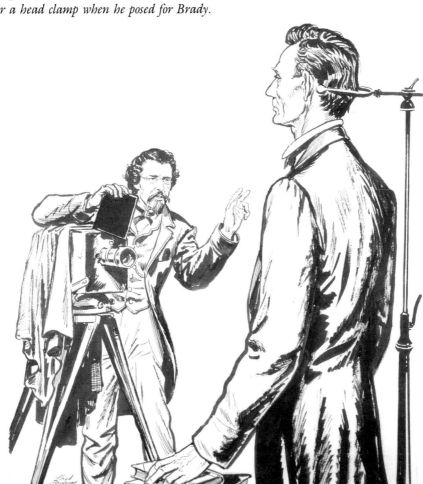

studio in the early days of daguerreotype photography had never seen a camera, much less posed for one. Some people were filled with dread. Often Brady's task was to get the subject to assume a natural yet dignified pose. He realized that people were usually more at ease when seated than standing. If sitting wasn't suitable, Brady then permitted standing subjects to lean. The studio provided a table, mantle, or other types of props for support.

At the same time, Brady supervised every other aspect of the studio's operation. He hired and fired all employees and supervised their work. He decided what cameras and lenses to buy. And he saw to it that a steady stream of customers climbed those three flights of stairs to his gallery's waiting room.

William Stapp, writing in *Facing the Light: Historic American Portrait Daguerreotypes*, calls daguerreotypes the "most beautiful of all photographic techniques." Each is rich and finely detailed.

Since it was produced on a highly polished mirrorlike plate, the daguerreotype image has an elusive quality to it; it flickers. The plate has to be held at just the right angle in order for the image to be visible.

As this suggests, the image can be seen clearly only by the person holding it. This makes for a direct and very personal link between the viewer and the person pictured. Photographs today, whether produced in black and white or color, do not have this quality.

Another characteristic of the daguerreotype portrait is that the subject almost always appears formal and dignified. This was at least partly because early daguerreotypists were deeply influenced by portrait painters of the time. They thus sought to capture the sitter's inner character, "the soul of the subject . . ." With that as the goal, one couldn't allow subjects to look frivolous. A slight smile might be permitted, but never a big grin.

It was not easy for the sitter. He or she had to keep absolutely still during the time of the exposure, which was at least fifteen seconds. Any movement resulted in a blurred image.

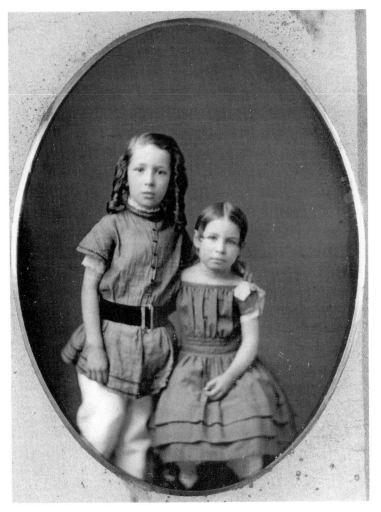

Children were photographed frequently at Brady's studio. A daguerreotype, from 1854 or 1855, portrays a somewhat anxious Elwyn Waller and his sister, Ella.

But attempting to hold a pose for so long a time could result in a blank stare. To avoid that, the sitter might be instructed to gaze at some distant object, instead of looking directly into the camera lens. *Photographic Art Journal*, in 1851, advised subjects to think serious or pleasing thoughts, depending on whichever expression they desired.

In the daguerreotype process, no negative was produced. There was

one plate, and only one. For copies, the daguerreotype itself had to be photographed.

The single plate the subject received when the sitting was over was very fragile. If not cared for properly, it tarnished. To protect the image, a piece of glass was put over the plate and the edges sealed with tape. A small case held the finished product and framed the image.

From the beginning, Brady faced stiff competition as a daguerreotypist. Dozens of studios had opened or were opening. According to research conducted by the New York Historical Society, there were some fifty "daguerreotype likeness" studios in New York City in 1850.

Despite the competition, success came quickly to Brady, at least in part because of his standards. By offering the highest salaries, he attracted the most talented camera operators and most knowledgeable chemists. He insisted on quality in every phase of the operation.

From the first, Brady's daguerreotype portraits were notable for their crispness, simplicity, and vitality, for their overall excellence. In 1846, the publication *Spirit of the Times* hailed Brady's work as "brilliantly clear and beautiful," with a quality of lighting and coloring that "surpasses anything we have ever seen in daguerreotypes."

In 1844, the same year that Brady opened his studio, the American Institute of the City of New York held the first of its annual contests to choose the best tinted and untinted daguerreotypes. Brady realized the importance of the competition, and entered, winning honorable mention in one category and second prize in the other. The following year, Brady was awarded first prize in both categories.

Not only did the prizes and awards tend to confirm the quality and artistic merit of Brady's work, they were good for business; they brought in customers.

From the first, Brady had a clear understanding of the value of advertising and publicity. He got an education in these arts from Phineas T. Barnum, known throughout much of his life as "The Great American

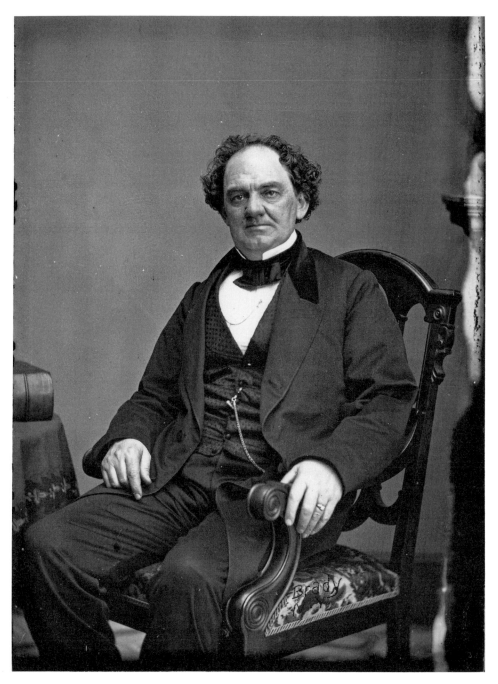

Showman Phineas T. Barnum posed at Brady's studio for this portrait.

Showman." Directly across Broadway from Brady's gallery, Barnum operated what he called the American Museum, which he had taken over in 1841.

At the museum, Barnum exhibited a "storehouse of the Earth's novelties for the study and enlightenment of all." These "novelties" included midgets, giants, fat ladies, skinny men, bearded ladies, Siamese twins, and other of nature's oddities whom Barnum employed.

The most noted of these wonders was Charles Sherwood Stratton, a midget who had been born in Bridgeport, Connecticut, on January 4, 1838. He weighed nine pounds, two ounces at birth, which is fairly large for a newborn. But by the time he was a year old, he had stopped growing at the normal rate. When he reached a height of two feet, 11 inches, he stopped growing altogether. Barnum created a new identity for young Charles, calling him "General Tom Thumb of England." The general and Barnum's many other attractions made their way across Broadway to be photographed at Brady's studio.

Barnum's rise to prominence paralleled that of Brady's. His circus, billed as "The Greatest Show on Earth," opened in 1871, and became an American institution. In 1881, ten years before his death, Barnum merged his circus with that of J. A. Bailey and, later, with John Ringling North's. The circus continues to this day under the name Ringling Brothers Barnum & Bailey.

Another friend Brady came to count upon was William Marcy Tweed, or "Boss" Tweed as he was known. At the same time Brady was making himself known for his excellence as a photographer, Tweed was rising in political circles. After winning control of the Democratic Party in New York City he became the dominant figure in the city's politics. In New York City in the 1850s, no one had more political influence than "Boss" Tweed. He and Brady were friends for more than two decades.

Although his business was flourishing, Brady was not content with photographing just anybody. By 1845, his second year of operation, he had decided that if he could coax the rich and famous to come before

his cameras, it would help to guarantee his success. He could achieve fame, he realized, by photographing the famous.

Brady began making and exhibiting portraits of the most notable people of the day—politicians and preachers, performers and writers, and, later, high military officers, visiting royalty, and American presidents.

Brady sometimes enticed notable individuals into his studio by not charging them for their photographs. The word "complimentary" was often written in Brady's ledger book after the names of congressmen, senators, and judges.

Brady's desire to photograph the great and near-great was based on something more than a desire for fame and financial success. He realized that he would be, in a sense, acting as a photographic historian. "From the first," he once said in an interview, "I regarded myself as under obligation to my country to preserve the faces of its historic men and women."

One of the first pictures of notable Americans that Brady displayed in his gallery was that of Andrew Jackson, the nation's seventh president. The photograph is believed to have been taken early in 1845, when the former president was ill and dying at his home, the Hermitage, in Nashville, Tennessee. For the photograph, the weakened President Jackson rose from his sickbed, dressed in formal clothes, and propped himself up in a chair with pillows.

Late in life, Brady claimed he "sent to the Hermitage" to have Jackson "taken barely in time to save his aged lineaments to posterity." But it is not likely that Brady ever met Jackson, who died in 1845. The photograph displayed in Brady's gallery is believed to have been taken by a young Nashville daguerreotypist named Dan Adams.

It *is* likely however, that Martin Van Buren, the eighth president, did pose for Brady. Although there is no record of the sitting, a photographic portrait of Van Buren, taken in 1848, seven years after he left office, was prominently displayed in Brady's gallery.

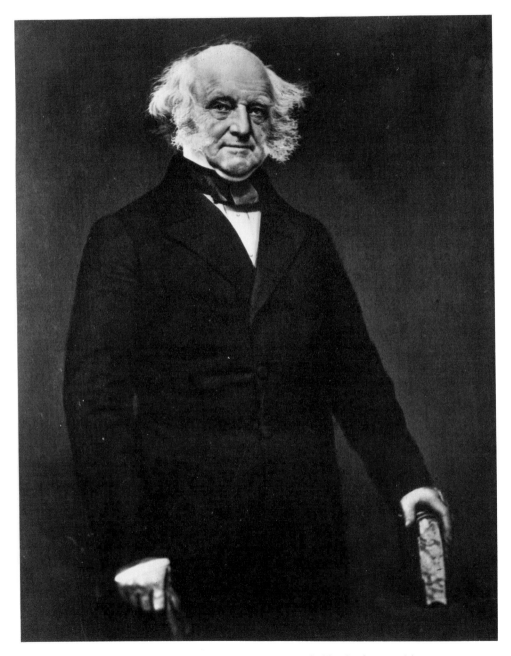

Martin Van Buren, the eighth president, was probably the first president to actually be photographed by Brady.

As for William Henry Harrison, the ninth president, he died in 1841, a month after his inauguration. There are no known photographs of him.

Harrison was succeeded by his vice president, John Tyler. Brady photographed Tyler in 1845, not long after his administration had ended.

Presidents were not the only notables that Brady photographed. One spring day in 1849, Edgar Allen Poe, the famous poet, short-story writer, and critic, visited Brady's studio quite unexpectedly. He was accompanying William Ross Wallace, also a poet, who had an appointment to sit for a portrait. Wallace introduced Poe to Brady, who must have immediately resolved to photograph his distinguished visitor before he left the studio.

When Brady had finished taking Wallace's photograph, he turned to Poe and asked him if he would be willing to sit for a portrait. Poe shook his head.

Brady guessed the reason that Poe refused was because he thought it would be too costly. So Brady, being as diplomatic as possible, explained there would be no charge to him, that he was an avid admirer of his, and wanted his portrait for the gallery. Wallace sought to persuade Poe, too. Finally, Poe consented.

The resulting portrait depicts Poe to be low in spirits, perhaps reflecting the sadness brought on by the death of his wife two years before. Poe himself died in October, 1849.

Brady not only operated a busy portrait gallery, he also functioned as a picture agency, selling copies of his photographs to anyone who sought them. It wasn't merely his own portraits that he sold. For example, his favorite image of Washington Irving, the author of *The Legend of Sleepy Hollow* and *Rip Van Winkle*, was not taken in his studio, but had been made by one of his business rivals, John Plumbe. Brady simply copied the photograph, stamped his name on the back, and sold it as his own.

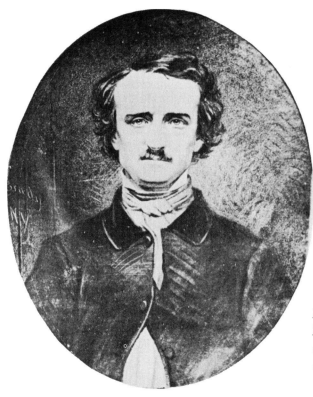

Poet and story writer
Edgar Allan Poe as he
appeared in Brady's
daguerreotype.

As this implies, there were different ethical standards in those days. The practice of copying was common among early daguerreotypists. Countless Brady photographs were copied by photographers far and wide, with no acknowledgment that Brady was at all connected with them. Copyright laws help to prevent this from happening today.

While Brady was a major success in New York, he did not limit his operations to that city. He traveled to Boston and Washington in his efforts to photograph people of distinction. Of course, on such trips, Brady had to haul all of his photographic gear—the big boxlike camera, the copper plates coated with silver, and the iodine, chlorine, and other chemicals.

On a visit to Washington, Brady met one of the city's oldest and most respected citizens, Mrs. Dolley Madison, widow of James Madison, the nation's fourth president. In 1848, at the age of eighty, Mrs. Madison agreed to pose for a Brady portrait. The sitting took place in her home on Madison Place, which formed the eastern boundary of Lafayette Park. Mrs. Madison remained active in Washington social affairs until her death in 1849.

Brady's portrait of James Knox Polk, the first president to be photographed in the White House.

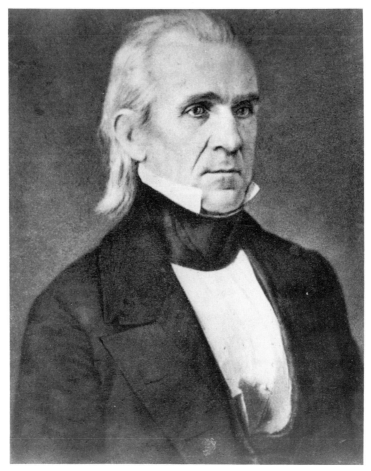

Mrs. Alexander Hamilton, the widow of the famous American states-man and first Secretary of the Treasury, also posed for Brady in Wash-ington. She was ninety-one years old at the time. The Library of Congress owns both of Brady's original daguerreotypes depicting these two women.

On yet another trip to Washington, Brady photographed James K. Polk, the eleventh president. Polk was, in fact, the first president to open the doors of the White House to Brady or any other photographer. The date was February 14, 1849. Polk's one term as president was drawing to a close.

When Brady, twenty-six or twenty-seven years old at the time, arrived at the White House, Polk came out of his office to greet him. Brady asked the president which room had the most light and Polk said the dining room. Brady suggested that they take the "likeness" there.

In the dining room, Brady opened the drapes and placed a chair near the window. When the president was seated, Brady adjusted the head clamp and focused the lens. Once the exposure was made, Brady packed up and left.

President Polk went to his study, where he made an entry in his diary. "February 14, 1849," he began, and then denounced the army of office-seekers that had been pestering him. He found them to be "willing to profess to belong to either party to obtain or hold office, all anxious to get in before I retire in hope that they will not be turned out after I retire. I have great contempt for such persons . . ."

More calmly, Polk included this information, "I yielded to a request of an artist named Brady of New York by sitting for my daguerreotype likeness today. I sat in the large dining room . . ."

3

Photographing the Famous

Brady had not been in business as a daguerreotype artist for very long before he decided to try his hand at publishing. His plan was to use his camera to record photographic portraits of the most famous Americans of the time, individuals he called "the greatest Americans since the death of Washington."

From the daguerreotypes he made, Brady would then have large detailed lithographic copies created by the noted French artist, Francis D'Avignon. Next, he would publish each of the lithographs in a volume to be titled *The Gallery of Illustrious Americans*, which he would market to the general public.

Daniel Webster, Henry Clay, and John C. Calhoun, three of the most noted figures in America's political history, were among the first individuals to be photographed for the "Gallery." Webster and Clay were in their late sixties at the time, and Calhoun was seventy-two.

In his biography of Brady, Roy Meredith explains that Brady planned to photograph Daniel Webster, a United States senator and Secretary of State, and one of the most renowned of American orators, on a visit to New York. Webster stayed at the Astor House, which was nearby Brady's studio. Charles Stetson, a close friend of Brady's and also a friend of Webster's, said he would do whatever he could to persuade him to visit the gallery to sit for his portrait. But Stetson explained he could not arrange a specific time. He said he would signal Brady when Webster was on his way by waving a handkerchief from a window in the Astor House. Brady assigned one of his employees to sit in a gallery window and watch for Stetson's signal.

It took two days of watching and waiting before the signal came. When his "lookout" gave him the good news, Brady peered out of the window to see Stetson and Webster crossing Broadway, heading for the studio. He immediately ordered screens and reflectors to be placed in their proper position and plates to be prepared.

Webster was puffing after climbing the three flights of stairs, according to Meredith, but he still managed to make a dramatic entrance. "Mr. Brady, I am here, sir!" he declared in a loud voice. "I am clay in the hands of the potter! Do with me as you please, sir!"

A total of three portraits were made during the sitting. They were probably the last taken of one of America's greatest statesmen, who died two years later.

Henry Clay, also a senator and Secretary of State, as well as Speaker of the House of Representatives, was known as the Great Compromiser for his ability to settle bitter disputes between Northern and Southern factions over the slavery issue. When he visited New York in the winter of 1849, Brady asked him to pose for a picture. Clay refused. He said he had no time to sit for a "counterfeit portrait," as he called it.

Brady was ready to accept Clay's refusal. Then he learned that several of Clay's friends, including William V. Brady, a former mayor of New

York City, wanted portraits of the Kentucky senator for themselves. They, along with Brady, convinced Clay to visit Brady's studio.

But on the day the sitting was scheduled, Clay did not appear. That same day a public reception was held in his honor at New York's City Hall, just a few blocks to the north of Brady's studio, and a huge throng of public officials and well-wishers turned out to cheer him. Overwhelmed by the crowd, Clay sent word to Brady to bring his equipment to City Hall and do the picture-taking there.

Brady had no choice but to pack up his camera, screens, reflectors, backdrops, and everything else and travel the few blocks north to City Hall. Several of his assistants went with him.

Although City Hall was jammed with Clay's friends and admirers when he arrived, Brady managed to find a room where Clay would pose. As Brady started to make preparations for the sitting, the room filled with spectators. They watched and chatted noisily as Clay took his seat in front of the camera. Some kept crossing back and forth in front of the lens. Brady couldn't recall ever facing such impossible conditions. However, when all seemed in readiness, Clay suddenly raised one hand and called for silence. Everyone froze. Clay placed his hands in his lap and calmly looked toward the camera as Brady exposed the plate.

John C. Calhoun, vice president under John Quincy Adams, a United States representative from South Carolina, a senator, Secretary of State, and a dedicated opponent of Webster's and Clay's, visited a studio Brady operated in Washington in 1849. The day was overcast and rainy, and Calhoun, realizing the only source of light was to come from the gallery's skylights, wondered whether Brady could expect to make a successful picture on such a cloudy day. Brady explained that while the lack of light was a problem, he could compensate by simply increasing the time of the exposure.

Calhoun sat for three portraits. His long hair, combed back, fell over his ears and almost reached his shoulders. But what Brady noticed most

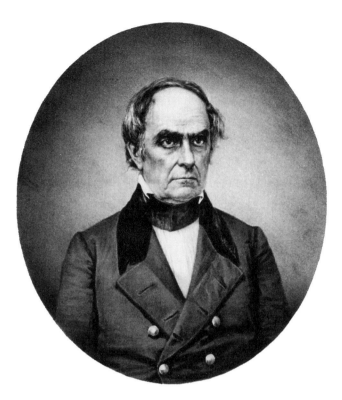

*Daniel Webster (left),
John C. Calhoun (below),
and Henry Clay (opposite),
three of the most celebrated
figures in American history,
were among those photo-
graphed by Brady and
featured in* The Gallery
of Illustrious Americans.

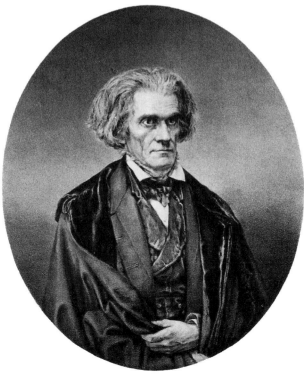

was Calhoun's gaze. Brady later said that "Calhoun's eye was startling and almost hypnotized me."

During the time Brady was involved in photographing Webster, Clay, and Calhoun, two of the most noted artists of the day, Richard F. Nagle and Henry Darby, were present. Nagle later painted an oil portrait of Webster. Darby made portraits of Clay and Calhoun. Both men based their works on Brady's daguerreotypes.

For years, Brady proudly displayed the three paintings at his New York gallery. In 1881, when Brady was deeply in debt, he was forced to sell the three paintings to the federal government. He received $4,000 for them. The money went to Levin Handy, Brady's nephew and often his assistant, to whom Brady owed many thousands of dollars. Today, the three paintings hang in the main corridor on the second floor of the Capitol Building's Senate extension.

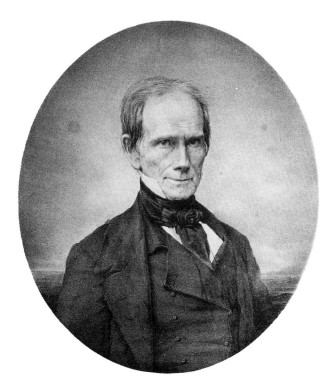

January 1, 1850, was named as the official publication date of *The Gallery of Illustrious Americans*. Besides Webster, Clay, and Calhoun, the *Gallery* featured two presidents, Zachary Taylor and Millard Fillmore; two generals, John C. Frémont and Winfield Scott; two senators, Lewis Cass and Silas Wright. Cass also served as Secretary of State. There was an historian, William H. Prescott; an artist, John J. Audubon; and an author and minister, William Ellery Channing.

Each of the twelve subjects is pictured facing away from the camera at a slight angle, looking off into the distance, except for Henry Clay, who looked into the lens. Each of the images is sharp and clear, simple and uncluttered, solemn and dignified.

Once Brady had completed his work, each photographic portrait was used to make a lithographic plate. From each plate, countless impressions could be made. The photographs for *The Gallery of Illustrious Americans* were rendered into lithographic portraits by Francis D'Avignon, who was paid $100 for each. They are, in fact, as much the work of D'Avignon as they are of Brady.

The twelve lithographs were bound in handsome leather covers and the title was printed in gold. The volume, which weighed five pounds, sold for $30, a hefty price at the time. While the huge book won glowing reviews from New York's daily newspapers, it did not sell well. Brady cut the price in half in an effort to stimulate sales but without much success.

Brady's original plan was for the *Gallery* to consist of twenty-four portraits, not merely twelve. Although the project loomed as a financial failure, Brady said he would produce all twenty-four portraits. Some sources say that he abandoned the project after twelve, while others claim he did not. However, no copies of a twenty-four-portrait volume are known to exist.

Although not a financial success, *The Gallery of Illustrious Americans* was a master stroke on Brady's part. Not only did the series of portraits

win him wide acclaim, the project served to stimulate Brady's business. After all, who wouldn't want to have their picture taken at the very studio where so many famous Americans had posed?

In March, 1849, even before the publication of *The Gallery of Illustrious Americans*, Brady embarked upon a new venture, opening another studio—"daguerrean rooms," as he called them—in Washington, D.C. While it was not as elaborate as his gallery in New York, it was suitably equipped to produce fine portraits.

From the beginning, Brady faced stiff competition in the nation's capital. John Plumbe, who had at least as much experience with the daguerreotype process as Brady himself, had been well entrenched in Washington for several years. Plumbe also operated studios in New York, Boston, Philadelphia, Baltimore, New Orleans, St. Louis, and several other cities. Plumbe was certainly a cause for concern.

Another of Brady's competitors in Washington was Edward Anthony, who also operated a studio in New York. Like Brady, Anthony put an emphasis on producing quality photographs. Edward's brother, Henry, was his partner. Henry concentrated on doing the actual photographing, while Edward operated a photo-supply business, selling plates, chemicals, and other supplies to daguerreotypists.

In Washington, one of the Anthonys' goals was to photograph every government leader and foreign notable. Copies of these images were to be sent to New York for display at the brothers' gallery there.

Besides the competition in Washington, Brady had difficulties with his landlord. Their dispute eventually ended up in court. Brady finally decided that Washington presented too many problems and gave up his operation there.

Brady's experience in Washington had a bright side, however. On one of his visits there, he met Julia Elizabeth Handy, a daughter of Col. Samuel Handy, a distinguished Maryland lawyer.

Julia Handy had been brought to Washington by her father many

years before, when he had taken on a government assignment in the capital. Her mother died when Julia was very young.

Only a few photographs of Julia Handy are known to exist. In these she appears as a serious and serene young woman, her oval face framed in dark curls.

James D. Horan, one of Brady's biographers, says that the setting for the romance that developed between Julia Handy and Brady was a beautiful Maryland plantation, a backdrop that included "parties, hoop-skirts, and young men who talked of nothing else but horses, duels, and manners of the time."

Julia and Mathew were married at the old E Street Baptist Church in Washington. Neither James Horan or any other source has managed to establish the date of the wedding, even after searching through available records and newspapers of the time. The best estimate is that the marriage took place in the late 1840s or early 1850s.

After their marriage, the couple lived at the fashionable National Hotel in Washington, but they did not stay there very long. After Brady closed his gallery in Washington, they moved to New York and made their home at the Astor House, the most elegant hotel of the time, located on Broadway near Brady's studio. Not only was the Astor House convenient, but it gave Brady the opportunity of meeting the many notables who stayed there on visits to New York.

The Bradys lived quietly and happily. They were sometimes seen together at the city's theaters and better-known restaurants. For relaxation, they liked to go on carriage drives in the country. Mrs. Brady often visited the gallery, bringing her friends with her.

In the summer of 1851, the Bradys set sail for Europe in the company of James Gordon Bennett, the founder and editor of the *New York Herald*, and his wife. The Bradys planned to be in Europe for almost a year. Brady left the New York studio in the hands of George S. Cook, a skilled photographer from Charleston, South Carolina. Within a dec-

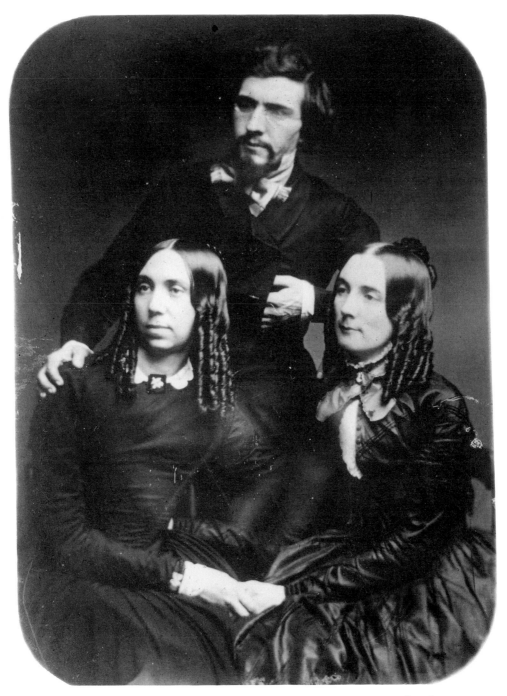

Mathew Brady with Julia Handy Brady (left) and Mrs. Haggerty, her sister.

ade, with the ordeal of the Civil War underway, Brady would be a photographer covering the Union forces, while Cook would be carrying out the same role for the Confederate armies.

Although he brought a camera with him, and had made plans to photograph a number of European notables, Brady's trip was also meant to be a vacation and honeymoon. In the seven years since he had opened his studio in New York, he had never taken a real vacation.

According to a New York photographic journal, one thing Brady intended to do in Europe was visit Louis Daguerre, the inventor of the process that Brady had raised to such heights. But Daguerre died while Brady's ship was crossing the Atlantic.

Earlier in 1851, Queen Victoria had opened the first great World's Fair in London. One of the outstanding events of the time, the fair had as its chief feature the Crystal Palace, a dazzling structure built entirely of glass over iron framework. The building covered twenty-one acres.

During the fair, awards were to be given for outstanding achievement in art, science, invention, literature, and photography. Approximately 700 pictures were entered in the photographic competition by daguerreotypists from six countries.

Some New York photographers sought unusual subjects to be photographed, hoping to create images that would be certain to catch the attention of the judges. One photographer placed an advertisement in *Humphrey's Journal* requesting "a man or woman over a hundred years old" to sit for a portrait. Another photographer's advertisement asked for a response from "a Revolutionary veteran." Since the American Revolution had ended in 1783, such a person would have to be around ninety years of age.

Brady wasn't interested in novelty. As his entry, he put together a group of what he felt were his best portraits, images of forty-eight notable Americans.

When the prizes were announced, they were swept by American daguerreotypists. Brady won a medal for the general excellence of his

work. John A. Whipple, a talented photographer from Boston, received a medal for a daguerreotype featuring craters of the moon, taken through the telescope at Harvard. Martin M. Lawrence, a competitor of Brady's in New York, was another winner. Lawrence received his medal for a photograph of three young women who were pictured facing to the left, forward, and to the right. The image was titled: "Past, Present, and Future."

The *Illustrated London News* called the Americans' daguerreotypes "super-excellent." The fair's official report on the competition said, "On examining the daguerreotypes contributed by the United States, every observer must be struck by their beauty of execution, the broad and well tinted masses of light and shade, and the total absence of all glare, which render them so superior to many works in the class."

Back in the United States, Horace Greeley, editor of the *New York Tribune*, crowed, "In daguerreotypes, we beat the world!"

After visiting the World's Fair in London, the Bradys toured France and Italy, journeying as far south in Italy as Naples. In many places of the world, Brady was pleased to find photographers advertising daguerreotype portraits "taken by the American process." He was also delighted to find his name and work were often well known.

BRADY'S EYES kept growing weaker and the lenses of his glasses kept getting thicker. In 1851, *Photographic Art Journal* noted that "Mr. Brady is not operating himself, a failing eyesight precluding the possibility of his using the camera with any certainty."

Despite his handicap, Brady continued to prosper. In March, 1853, he opened a second studio in New York. It was located at 359 Broadway, a mile or so farther uptown than his Fulton Street gallery. The fact that the ground floor was occupied by a saloon, a place where alcoholic drinks were served, was not looked upon as being at all objectionable to Brady. Saloons were acceptable in those days. In fact, Brady advertised the new studio as being "over Thompson's Saloon." He realized that New Yorkers

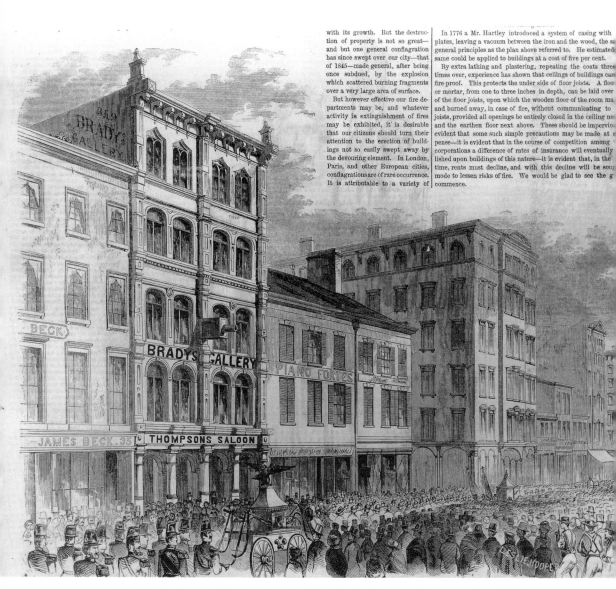

with its growth. But the destruc-
tion of property is not so great—
and but one general conflagration
has since swept over our city—that
of 1845—made general, after being
once subdued, by the explosion
which scattered burning fragments
over a very large area of surface.

But however effective our fire de-
partments may be, and whatever
activity is extinguishment of fires
may be exhibited, it is desirable
that our citizens should turn their
attention to the erection of build-
ings not so easily swept away by
the devouring element. In London,
Paris, and other European cities,
conflagrations are of rare occurrence.
It is attributable to a variety of

In 1776 a Mr. Hartley introduced a system of casing with
plates, leaving a vacuum between the iron and the wood, the sa
general principles as the plan above referred to. He estimated
same could be applied to buildings at a cost of five per cent.

By extra lathing and plastering, repeating the coats three
times over, experience has shown that ceilings of buildings can
fire-proof. This protects the under side of floor joists. A floo
or mortar, from one to three inches in depth, can be laid over
of the floor joists, upon which the wooden floor of the room ma
and burned away, in case of fire, without communicating to
joists, provided all openings be entirely closed in the ceiling ne
and the earthen floor next above. These should be impervio
evident that some such simple precautions may be made at a
pense—it is evident that in the course of competition among
corporations a difference of rates of insurance will eventually
lished upon buildings of this nature—it is evident that, in the
time, rents must decline, and with this decline will be soug
mode to lessen risks of fire. We would be glad to see the g
commence.

Brady's Gallery at 359 Broadway in New York City, which he opened in 1853.

knew the location of Thompson's better than the address of 359
Broadway.

On the top floor, Brady ordered a huge double-faced skylight, shaped
like a pointed roof. It poured light into a studio where daguerreotypes

requiring special lighting effects were made. Most standard portrait daguerreotypes were taken two floors below, where studios were available that offered either northern light or southern exposure. The top floor also provided storage areas for chemicals and other supplies.

It was the gallery's lavish interior spaces that caused the most comment. "The Reception Rooms are up two flights of stairs, and entered through folding doors, glazed with the choicest figured cut glass, and artistically arranged," said *Humphrey's Journal*, the leading photography

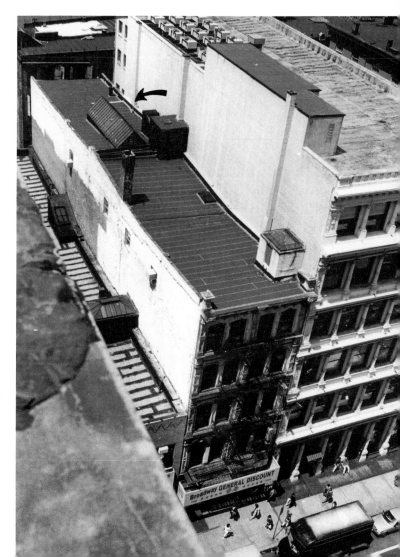

A recent photograph of the building at 359 Broadway that once housed Brady's studio. Skylights (arrow) are still in place.

publication of the day. "The floors are carpeted with superior velvet tapestry, highly colored and of a large and appropriate pattern. The walls are covered with satin and gold paper.

"Suspended on the walls, we find the Daguerreotypes of Presidents, Generals, Kings, Queens, Noblemen . . . men and women of all nations and professions.

"Adjoining the Reception Rooms is the business office of the establishment [that is] fitted up with a variety of showcases, where can be seen samples of all the various styles of Frames, Cases, Lockets, etc., used in the Art."

The building at 359 Broadway is still in existence. It looks down on a busy commercial area. The top floor, where Brady's studio was once located, is now occupied by a Buddhist Meditation and Study Center and features the Kalachakra Peace Chapel. The skylight is still in place. It takes the form of a gable roof, that is, it slopes downward in two parts at an angle from a central ridge.

In the late 1980s, when the building's owner sought to have the structure torn down to make way for a skyscraper, the tenants resisted the move. They were successful in having the building designated as an official city "landmark" because of Brady's association with it. In testimony before the Landmarks Preservation Commission, the building was cited as where "Brady's skill and technique developed, along with the fledgling art and science of photography." By being designated a landmark, the building is protected against demolition.

4

The Prince of Photographers

At about the same time Mathew Brady was getting ready to open his new studio in New York City, the technique of picture taking was undergoing important change. The change was so profound that by the early 1860s the daguerreotype, which had typified photography almost since its invention, would be all but obsolete.

What replaced the daguerreotype was a process that enabled the photographer to produce a negative. From the negative, countless paper prints could be produced. This is the process upon which all modern photography is based.

The advance involved making a negative impression on a chemical-coated slab of glass (instead of making a positive imprint on a chemical-coated metal plate, as demanded by the daguerreotype). It was called the wet-plate process.

The wet-plate process was introduced by Frederick Scott Archer, a

British photographer, in 1851. In the Archer method, a glass plate was coated with a mixture of silver salts and a wet and sticky substance called collodian. After being exposed in the camera for only a few seconds, the glass plate could be developed into a negative. (It was called the "wet-plate" process because the freshly coated glass plate had to be exposed and developed before the emulsion dried.)

Once the negative had been properly treated, it could be used to make as many prints as the photographer wanted. Negatives could also be used to make enlargements, of course.

While Brady had seen wet-plate photography demonstrated on his visit to England, and was aware of its many advantages, he was in no hurry to adopt the process. Perhaps he did not fully understand the chemistry involved.

John Adams Whipple of Boston, whose daguerreotype showing the craters of the moon that had captured one of the prizes at the World's Fair in 1851, had been experimenting with wet plates even before the 1850s. Whipple became the first American photographer to master the process. When Whipple's paper prints won the highest photography prize in the New York Crystal Palace exhibition in 1853, Brady and other photographers became convinced that the wet-plate process represented the wave of the future.

Whipple called wet-plate photography "crystalotype" (because of the crystal-clear character of the glass negative). For fifty dollars, he offered to sell the rights to use the patented process. For another fifty dollars, he would provide instruction in the art. The leading photographers of the day made their way to Whipple's studio in Boston for training in wet-plate photography. Brady is believed to have been among them.

Photography grew by leaps and bounds after the introduction of the wet-plate process. Not only did it permit photographers to make countless duplicates of their photographs, it enabled them to take photographs more easily in different types of situations. For instance, it became easier

to take outdoor photographs. The Civil War was photographed by camera operators using the wet-plate process.

Photography was still very cumbersome, however, still largely the domain of the professional. The photographer had to mix the proper

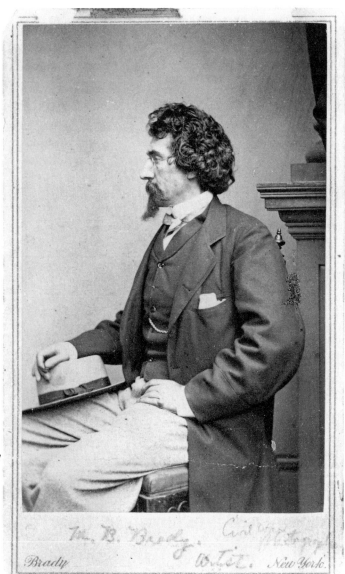

A carte-de-visite
portrait of Mathew Brady
taken at his studio
about 1861.

chemicals in the right proportions, apply them to the glass plate in just the right amount, expose the plate in the camera, then develop the plate almost immediately—and do all of this before the emulsion dried.

The photographer was still firmly linked to the darkroom. Outdoor photography required a portable darkroom, a tent or horse-drawn wagon.

IN 1856, Brady made an important move when he hired Alexander Gardner, an experienced photographer and efficient businessman, who had recently arrived in the United States from Scotland. Among the photographers of the late 1800s, Gardner is looked upon as the most skilled and versatile. The poet Walt Whitman called Gardner "a real artist" and "a man with a big head full of ideas." The lives of Gardner and Brady were to be closely linked for almost a decade.

Gardner, two or three years older than Brady, came from a well-to-do family of Scottish ministers and doctors. Besides his excellence as a photographer, Gardner was well schooled in chemistry and astronomy. He also prided himself on his knowledge of bookkeeping and statistics and business ability.

Among Gardner's earliest innovations were huge portraits, ones that were 17 by 21 inches in size. Brady called them "Imperials" and charged anywhere from $50 to $750 apiece for them. Once matted and framed, an Imperial occupied as much wall space as a large poster.

The amount that Brady charged for an Imperial often varied with the amount of retouching the portrait required. When the image was enlarged, the subject's wrinkles, blemishes, and other facial defects also increased in size. So Brady employed clever retouchers who could remove all such imperfections, smooth rumpled clothing, straighten one's tie, or improve one's hairdo. With their India ink and charcoal, a retoucher could even change the turn of a lip or the arch of an eyebrow. A more pleasing appearance was the result.

Besides producing Imperial prints, Gardner put his business skills to

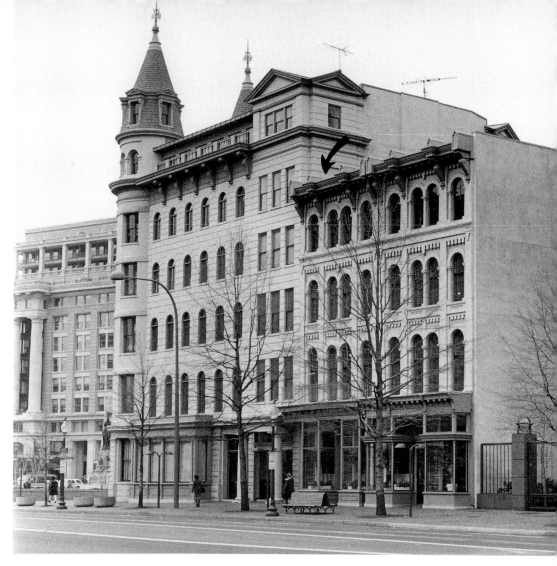

The building second from right, located on Pennsylvania Avenue near Seventh Street, housed Brady's Washington studio.

work. He got Brady to hire a bookkeeper and install professional accounting procedures, matters he had neglected in the past. As a result, Brady became even more prosperous.

With his operation in New York thriving, Brady decided to try Washington again, and announced plans to open a new studio there. In Alex-

ander Gardner, Brady knew he had the man to run it. He gave the studio a grand name—the National Photographic Art Gallery.

Located on Pennsylvania Avenue between Sixth and Seventh streets, the studio featured many of the same attractions that had proven successful in New York. Enlarged images of the rich and celebrated adorned the entrance hall and waiting rooms. Washingtonians were invited to visit the gallery and see the famous faces. There was also a glass case at the sidewalk entrance where the studio's most recent works were displayed. The camera operators were assigned to the top floor, where skylights had been installed.

The operating room was equipped with two cameras, four head clamps, four painted screens used as backgrounds, several reflecting screens, and three posing chairs, including one for children.

Brady didn't use many props in his photographs, but those he did use he used over and over. Perhaps the best known was an ornate gold clock. The time on the clock is always 11:52.

A heavy, hand-carved oak chair upholstered in black leather was used frequently for seated poses. According to legend, the chair belonged to Abraham Lincoln. In truth, however, it was the property of the U.S. House of Representatives. It bore the shield of the United States on the top of its high back. Several straight chairs were also available for posing.

A dressing room was available where customers could prepare themselves for a sitting. In the room, there was a marble-top washstand, a washbowl, a water-filled pitcher, and towels.

Brady remained in New York and left operations in Gardner's hands. Among his employees, Gardner had his brother, James, and Timothy O'Sullivan, a young apprentice photographer with a bright future.

Gardner did about everything in Washington, from arranging bookings to supervising the camera operators, from managing the laboratory to sending out the bills. But everything Gardner did, he did anonymously, for every image that left the studio carried the credit line: "Photo by Brady." Eventually this policy was to cause conflict.

Gardner and his operators tried different techniques to improve the quality of their photographs. During the first year of operation, according to local newspapers, they experimented with the use of artificial lighting to illuminate their subjects. Brady, in his later years, claimed that all portraits were done in natural light exclusively. But the gallery in Washington operated independently of Brady, and it is not unlikely that artificial lights were given a try.

IN THE LATE 1850s and early 1860s, Brady's operations in both Washington and New York became involved in a new photographic craze, the *carte de visite* (visiting card). A French innovation, the *carte de visite* or card photograph, took the form of a 2¼ by 3½-inch photograph mounted on a 2½ by 4-inch card. In other words, it was about the size of a bubble gum baseball card of the present day, although a bit slimmer.

Card photographs could be made cheaply and produced in huge quantities. It soon became the rage to collect and exchange cards. They depicted not just friends and relatives, but presidents and government leaders, clergymen and noted literary figures, prominent women, and generals of the Army and officers of the Navy.

It wasn't long before manufacturers began to supply albums in which the card photographs could be easily mounted. The albums became family photographic records, their archives. For the first time in American history, photography was being mass-marketed. Photographers could scarcely keep up with the demand.

Brady, while he was to reap financial benefits from the mania, was not excited by it. The little pictures, which sold for twenty-five cents apiece, cheapened photography, he felt. And producing them required little in the way of skill or artistry. It was more like being a printer than a photographer.

Gardner, however, recognized the commercial potential of card photographs, and was quick to capitalize on the demand for them. He ordered a special four-lens camera that enabled operators to quadruple

the number of prints and negatives that could be made from a single pose.

The number could even be redoubled by using a glass plate large enough to accommodate eight images. After the first four pictures were made, the operator removed the plate from the camera and put it back in upside down. Four additional exposures could then be made. Once a print had been made from the plate, the eight pictures were cut apart and mounted separately.

The Washington gallery included a mounting room where this work was performed. It contained two presses for mounting the photos to the cardboard, and stacks of mats, cards, boxes of albums, and tall racks holding prints in strainers.

As the demand for card photographs continued to spiral upward, putting a heavy strain on Gardner's mounting room operations, he suggested to Brady that he enter into an arrangement with Edward Anthony and his older brother, Henry, who operated the largest photographic supply house of the time, to make the needed prints as orders were received. Brady agreed it was a good idea.

Under the terms of the contract that was worked out, Brady's negatives of famous people were sent to the Anthonys in New York. The Anthonys made and sold prints from the negatives and sent Brady a share of the profits. On the reverse side of each card photograph, the print was identified as having been made from a Brady negative. According to his financial records, Brady received about $4,000 a year from the arrangement.

AS NEW YORK CITY expanded and pushed northward, Brady moved north, too. His first gallery in New York, which he had opened in 1844, was located at 205 Broadway. He moved to 359 Broadway in 1853. He

A sampling of carte-de-visite *portraits produced by Brady's New York studio.*

Brady's studio at 785 Broadway in New York City, across from Grace Church, which he opened early in 1860.

opened an even more lavish gallery at Tenth Street and Broadway—785 Broadway—early in 1860.

The gallery was across the street from Grace Church and a wondrous new department store erected by A. T. Stewart, Brady's first employer in New York. *Frank Leslie's Illustrated Magazine* hailed the Brady operation for its "costly carpet . . . elegant and luxurious couches . . . [and] elegant and artistic gas fixtures."

Brady installed a private entrance at the new gallery for ladies arriving

in formal dress. It led directly to the operators' rooms. No longer would ladies in hoopskirts and crinolines have to pass through the public gallery.

Leslie's also praised the new gallery for the "countless exquisite pictures which fill every available inch of the walls." The newspaper called

Interior of Brady's lavish gallery at Broadway and Tenth Street in New York.

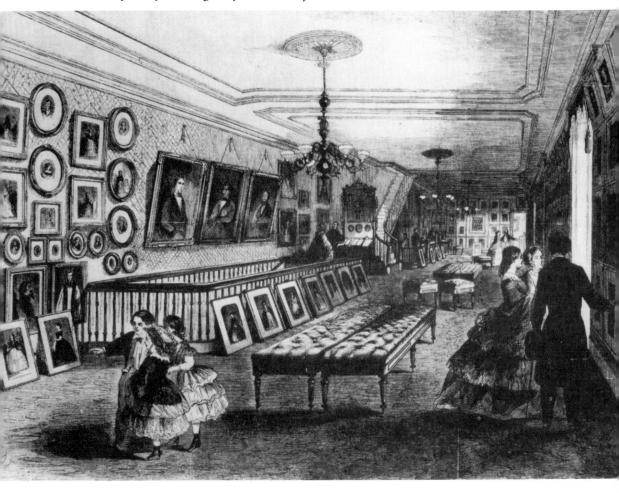

the images of bankers, clergymen, scholars, lawyers, doctors, orators, and statesmen "a portrait history of the times."

The same year the new gallery opened, the nineteen-year-old Prince of Wales, the future Edward VII, visited New York. (The present Prince Charles of England, the oldest son of Queen Elizabeth II, is the great-great-grandson of Edward VII and bears a striking resemblance to him.) New York was in a frenzy over the visit of the Prince. It was the first visit ever to the United States by a member of the British royal family. New York's firemen staged a loud and enthusiastic torchlight parade past the Fifth Avenue Hotel where the Prince was staying. The Prince watched from a hotel balcony. A dazzling ball held in the Prince's honor attracted the city's rich and famous and lasted until the early morning hours.

All of New York's photographers sought the opportunity to photograph the Prince. Not only would it be a great honor, it would be a financial bonanza. Card photographs of the Prince would be certain to rack up tremendous sales.

On the morning of October 13, 1860, Brady was asked to come to the Prince's hotel to make arrangements for a visit to the gallery. When the two met, the Prince suggested that Brady close the gallery to the public during the afternoon, which Brady quickly consented to do.

Shortly before noon, the Prince and his royal party left their hotel in carriages. Crowds followed the procession, cheering and waving. The carriages stopped on Tenth Street near Broadway, at Brady's studio. Brady was waiting to greet the Prince and guide him through the gallery. *Leslie's Illustrated Weekly* noted: "The Prince immediately began inspecting with curious interest the portraits of the statesmen and other celebrities of this country."

In the operating room, the Prince posed alone and then with the members of his party. Brady took a full-length portrait of the Prince, three Imperial portraits, and a number of portraits for use as card photographs. Afterward, the Prince and his party signed Brady's guest register.

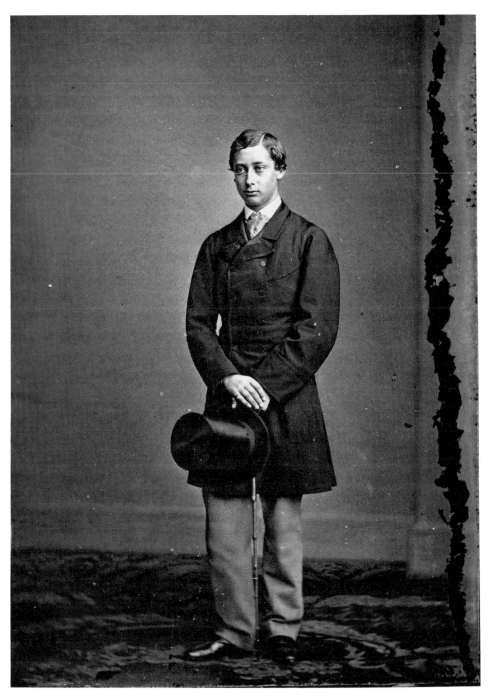

One of Brady's photographs of the Prince of Wales, taken during his visit to New York in 1860.

Brady accompanied the royal party to the street, where their carriages were waiting. By that time, the crowd was so large that police had been called to keep control. Before the Prince stepped into his carriage, he turned to shake hands with Brady one last time.

Years later, Brady disclosed that during the Prince's visit he had asked the Duke of Newcastle, a member of the Prince's party, what had caused him to come to his studio. The Duke said: "Are you not Mr. Brady who earned the prize nine years ago in London? You owe it to yourself. We had your place of business down in our notebooks before we started."

As momentos of the occasion, the Prince sent gifts to the Bradys. Mrs. Brady received an ebony escritoire, a small writing desk lined in green velvet with silver trimmings. Brady received a gold ring and a rosewood cane with a carved ivory handle bearing the inscription: "M. B. Brady, from Edward, Prince of Wales."

By 1861, Mathew Brady, approaching the age of forty, was at the peak of his fame. He had become a man of wealth, with important holdings in stocks and real estate. His collection of images of the noteworthy had grown to several thousands. His galleries in New York and Washington were doing a thriving business.

The *New York Times* called him "the prince of photographers . . ." And two years later, in 1863, *Harper's Weekly* said of Brady: "When the history of American photography comes to be written, Brady, more than any other man, will be entitled to rank as its Father."

5

Brady and Lincoln

In February, 1860, not long after Brady had opened his gallery on Broadway at Tenth Street in New York, Abraham Lincoln paid a visit. The meeting of Brady and the tall lawyer from Illinois, then fifty-one and who later in the year was to be elected to his first presidential term, resulted in one of the most famous portraits ever taken by Brady.

Lincoln had been invited to New York to address the congregation of Henry Ward Beecher's church in Brooklyn. Several leading Republicans, however, persuaded him to deliver the speech at Cooper Institute, a free school of arts and sciences in Manhattan, instead of in Brooklyn. Once the Reverend Beecher approved, Lincoln agreed to the change.

On Monday morning, February 27, members of the Young Men's Central Republican Union met Lincoln at the Astor House, where he was staying, and escorted him up Broadway to Brady's studio, where Brady had begun making preparations for the sitting. Lincoln's physical

appearance presented problems. The *Houston Telegraph* described the future President as ". . . the leanest, lankest, most ungainly mass of legs and arms and hatchet face ever strung on a single frame," then added, "He has abused the privilege . . . of being ugly."

Brady decided to pose Lincoln standing, with one hand placed on a book, the other at his side. But Brady had trouble getting what he called a "natural" picture. Finally, he asked Lincoln if he would "arrange" his shirt collar.

Lincoln grinned, realizing what Brady had in mind. He then began pulling up his loose collar. "Ah, I see you want to shorten my neck," Lincoln said.

"That's just it, Mr. Lincoln," Brady replied. The incident served to relax Lincoln.

That night at Cooper Institute, Lincoln was introduced to an audience of some 1,500 by the famous poet and editor William Cullen Bryant. The huge throng was absorbed by Lincoln's words of reason and good sense. He did not call for the elimination of slavery overnight, but he did propose that slavery should not be extended into the new territories of the expanding nation.

Lincoln closed with these words: "Let us have faith that right makes might, and in that faith, let us, to the end, dare to do our duty as we understand it."

Less than twelve weeks later, Lincoln was nominated by the Republicans as their presidential candidate. The photograph that Brady had taken was used extensively during the campaign. It appeared as an engraving in *Harper's Weekly* and in countless other publications. It was duplicated by the tens of thousands as a card photograph and was also reproduced on banners and buttons. Currier and Ives made lithographs from it. Later, when Brady visited the White House, Lincoln is said to have remarked, "Brady and the Cooper Institute made me President."

In the years after his election in 1860, Lincoln became something of an industry for Brady. Not only did Brady and his operators photograph

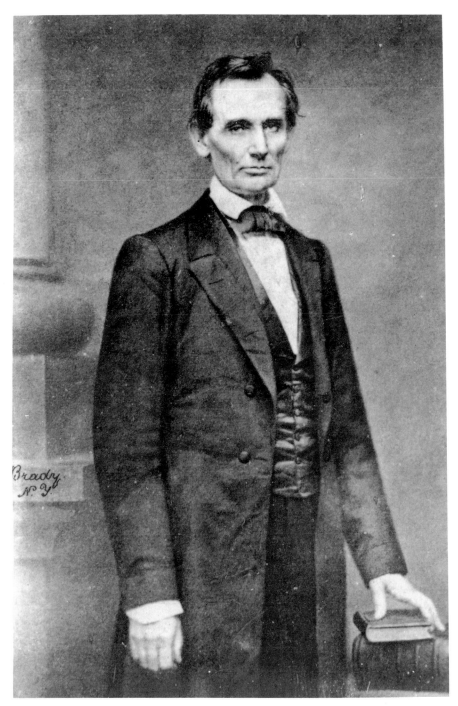

The famous Cooper Institute photograph of Abraham Lincoln, taken by Brady early in 1860.

the president on many occasions, they also photographed members of his family, his close friends, the members of his cabinet, the members of Congress at the time, and even Lincoln's enemies. John Wilkes Booth, who assassinated the president in 1865, was about the only well-known individual with a connection to Lincoln who managed to escape Brady's cameras.

According to Charles Hamilton and Lloyd Ostendorf, authors of *Lincoln in Photographs, An Album of Every Known Pose*, Lincoln, during his lifetime, sat for thirty-three different cameramen who produced 126 different photographs.

Alexander Gardner photographed Lincoln thirty times, more than anyone else. Many of Gardner's photographs were taken at Brady's Washington studio on Pennsylvania Avenue, while he was employed by him.

Anthony Berger, who joined Brady in Washington in 1863 or 1864, is second to Gardner, with thirteen Lincoln photographs, all posed at Brady's studio. Brady or his camera operators are believed to have photographed Lincoln eleven times.

The first session in Washington involving Lincoln took place at Brady's gallery on February 24, 1861. *Harper's Weekly* had assigned Brady to photograph the newly elected president upon his arrival in Washington from his home in Springfield, Illinois. It was a long, exhausting journey, covering nearly two thousand miles through seven states. At various stops during the trip, Lincoln shook hands with admirers. The thousands of hands he shook caused his right hand to swell. During the photo session, Lincoln kept the swollen hand closed or tucked out of sight.

Alexander Gardner, who was in charge of Brady's studio at the time, took five poses that day. A young artist, George Story, a friend of Brady's who had taken a studio in the same building as Brady's gallery, once recalled the session: "A day or two after the President's arrival [February 23, 1861], Mr. Gardner, Mr. Brady's representative in Washington, came to my room and asked me to come and pose Mr. Lincoln for a picture. When I entered the room, the President was seated in a chair wholly

absorbed in deep thought . . . I said in an undertone to the operator,
'Bring your instrument here and take the picture.' " Gardner used a two-
lens and then a three-lens camera in taking the pictures.

During the session, Lincoln, who dressed in his best attire for the

*Alexander Gardner took this photograph at Brady's gallery in Washington several
days before Lincoln's inauguration on March 4, 1861.*

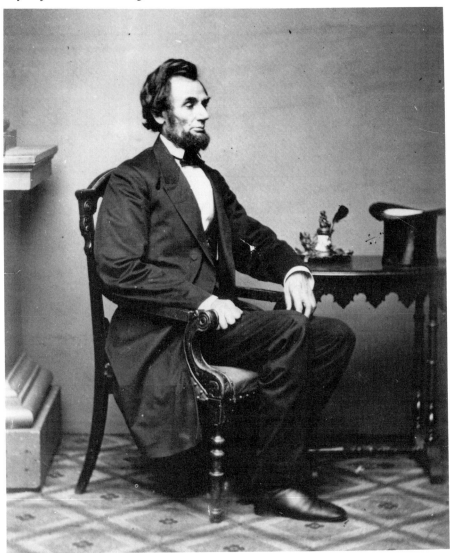

occasion, scarcely moved. John G. Nicolay, Lincoln's private secretary, described the president as having a "serious, far-away look." *Harper's Weekly* published an engraved reproduction of one of the photographs in its issue of April 27, 1861.

Lincoln's inauguration was scheduled for March 4, 1861. Brady himself made plans to photograph it and applied to authorities for credentials that would enable him to get close enough to the oath-taking ceremony to make a clear picture of it.

But Allan Pinkerton, who had guarded Lincoln on his trip to Washington, believed the president's life was in danger. To guard against an assassination attempt, sharpshooters had been stationed along Pennsylvania Avenue and troops were posted near the Capitol steps on the morning of the inauguration. A few hours before the inauguration, a report was received that a bomb would be exploded under the wooden platform on which the ceremonies were to take place.

When Brady and two of his operators arrived that morning to set up their equipment, they were given no special privileges and had to station themselves a long distance from the ceremonies. While their photographs captured part of the crowd and the Capitol Building (with its unfinished dome), it was impossible to make out the figure of Lincoln.

Lincoln made his second visit to Brady's Washington studio in 1862. This time Brady and his assistants made an Imperial photograph of the president, which now ranks as the largest known Lincoln photograph. The image is recorded on a glass plate that measures 18½ by 20⅜ inches. After the Imperial photograph was taken, Brady used a multi-lens camera to take other photographs, which were very similar to the first.

When Lincoln visited Brady's gallery on April 17, 1863, Brady's operator at the time, Thomas Le Mere, told him that there was quite a demand for a new standing portrait of the president. Lincoln, who often joked about his height, said, "Can it be taken with a single negative?" Apparently, the answer was "No," for Le Mere's photograph cuts off the president at the ankles.

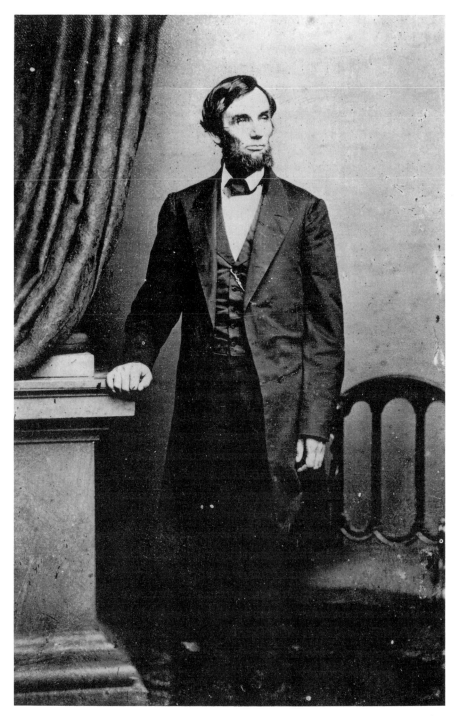

Another standing pose of Lincoln, taken by Thomas Le Mere at Brady's gallery in Washington on April 17, 1863.

A number of photographs of Lincoln were produced as stereographs, or stereo cards, as they are sometimes called today. Stereographs are paired photographs of the same image taken from slightly different points of view. When the paired images are viewed through a special optical instrument called a stereoscope, the viewer sees a single image in three dimensions. At one time, virtually every American family had a collection of stereographs and a stereoscope. Home viewing was almost as popular as television is today.

Special stereo cameras, each with two lenses mounted several inches apart, were developed that could photograph the paired views simultaneously. Besides portraits, all kinds of scenic views were photographed for stereo cards. Many Civil War photographs were also produced for stereo viewing.

During the period from 1858–1865, Edward Anthony and Frederick and William Langenheim were the leading publishers of stereo cards. In 1862 alone, Anthony sold several hundred thousand of the double-photo, rectangular cards with rounded corners. The cards remained popular well into the 1900s.

What have become perhaps the best-known photographs of Lincoln were taken at Brady's gallery in Washington on February 9, 1864. Anthony Berger was the photographer. Brady is believed to have been there that day, helping with the posing and performing other chores.

In one series of photographs taken that day, Lincoln appears in profile. Sculptor Victor D. Brenner used this pose to model the portrait of the president that appears on the Lincoln-head penny. In another pose, the president is seated, looking stern and serene. This portrait served as the basis for the engraving of Lincoln that appears on the five-dollar bill.

Yet another picture taken by Anthony Berger at Brady's gallery on February 9, 1864, included Lincoln's son, Thomas, known as "Tad," who was ten years old at the time. The two are pictured looking at a big photograph album. The photograph was published in many different

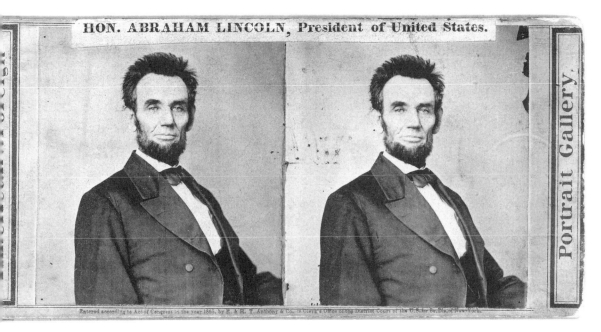

A stereo card depicting Lincoln, published by E. & H. T. Anthony in 1865. Lewis E. Walker is believed to have been the photographer.

When the paired images of a stereo card were viewed through a stereoscope, viewer saw a single image in three dimensions.

This is called the "penny profile" of Lincoln. Taken by Anthony Berger at Brady's Washington gallery on February 9, 1864, it was used by sculptor Victor D. Brenner in modeling the portrait of the president that appears on the Lincoln penny.

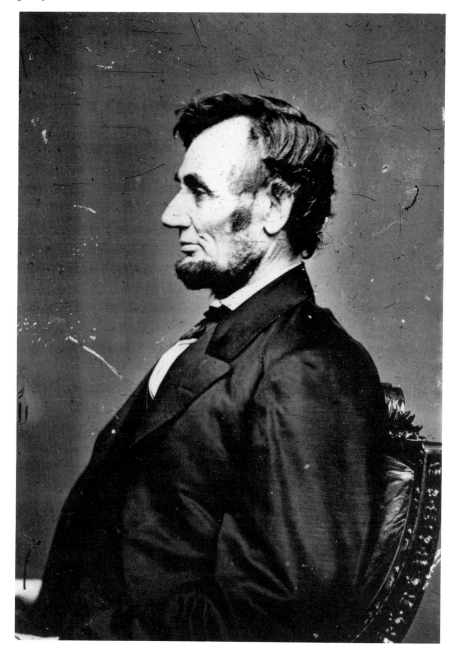

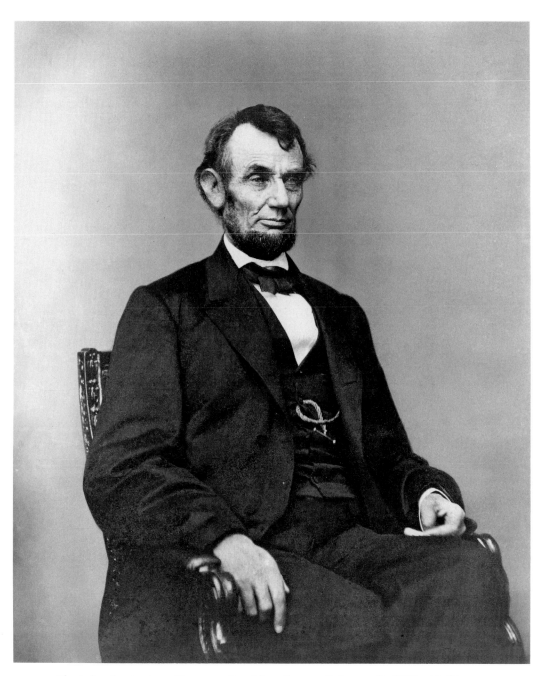

Also taken by Anthony Berger at Brady's gallery on February 9, 1864, this likeness of Lincoln was used as a basis for the engraving of Lincoln that appears on the five-dollar bill.

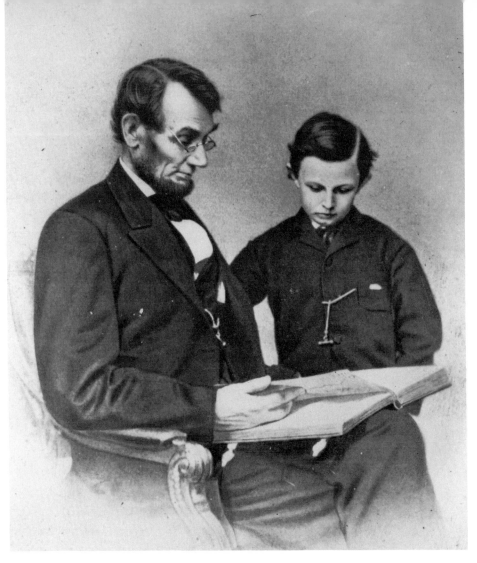

One of the most popular of all Lincoln photographs pictured the president with his son, Tad, ten years old at the time.

forms—as a card photograph, an engraving, lithograph, and painting. Copied by other photographers, it was turned out in enormous quantities.

Late in April, 1864, Lincoln returned to Brady's studio for another photo session. Again, Anthony Berger was the photographer. Berger also photographed Lincoln at the White House that month.

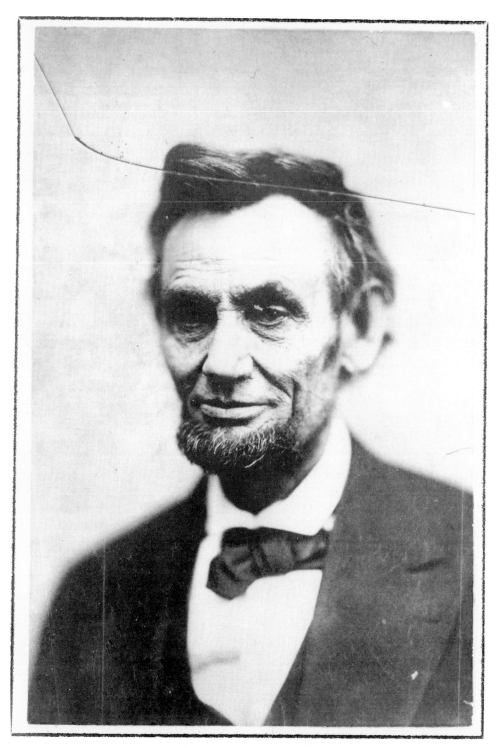

The final portrait of Lincoln, photographed by Alexander Gardner on February 5, 1865. The president was assassinated several weeks later.

The last formal portraits of President Lincoln were taken by Alexander Gardner in 1865. Several years before, Gardner had left Brady and established his own studio in Washington not far from the White House. On February 5, 1865, Lincoln visited the studio.

After the president had posed for several pictures, Gardner moved in for a final portrait, a close-up. The glass plate bearing the image cracked during processing. After a single print had been made, Gardner discarded the damaged plate. After all, he may have figured, the president, who had been reelected the previous November, would be in office for four more years. There would be plenty of opportunities to make photographs. But on April 14 of that year, Lincoln was shot at Ford's Theatre. He died early the next morning.

Not long after Lincoln's assassination, Andrew Johnson, who had taken office upon Lincoln's death, went to Brady's gallery to sit for a portrait. Brady posed him in the same chair that had been used for Lincoln's sittings.

On May 5, 1865, the Washington *Daily Chronicle* noted that Brady had taken the first picture of Johnson as president. "Like all of Brady's works," said the newspaper, "it is easy in position, bold in outline, clear in finish, and true as life itself."

6

"My Feet Said 'Go!'"

Of all the events in American history, perhaps none has had the impact of the Civil War. It took more lives than any other war in American history and touched virtually every American home with sadness or bitterness, or both.

It began on April 12, 1861, when Southern troops fired on Fort Sumter, a federal military post in Charleston, South Carolina. It continued for four years, until April 9, 1865, when Confederate Gen. Robert E. Lee surrendered to Union Gen. Ulysses S. Grant.

The Northern victory determined that the nation would be a permanent union of states. No state or confederation of states had the right to end the union.

And the Civil War also settled the slavery issue. The 13th Amendment to the Constitution, ratified soon after the war, officially ended slavery throughout the United States.

In the early months of 1861, as the war clouds gathered and Northern volunteers flooded into Washington, Brady's gallery was all but over-whelmed by customers. As each new soldier was issued a uniform, he rushed to a photographic studio to have his picture taken for his loved ones back home.

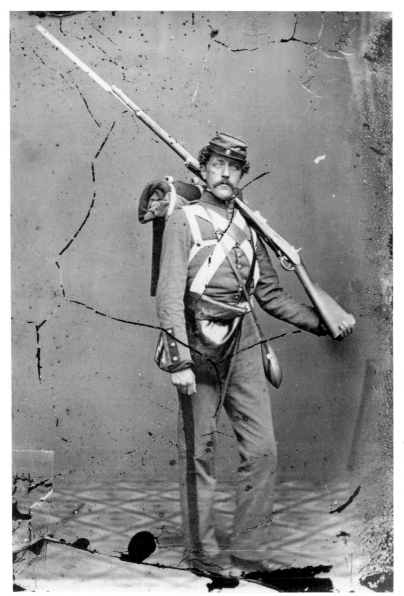

In the early days of the war, Union volunteers crowded Brady's Washington gallery to have their pictures taken to send to loved ones at home. This was taken in 1861.

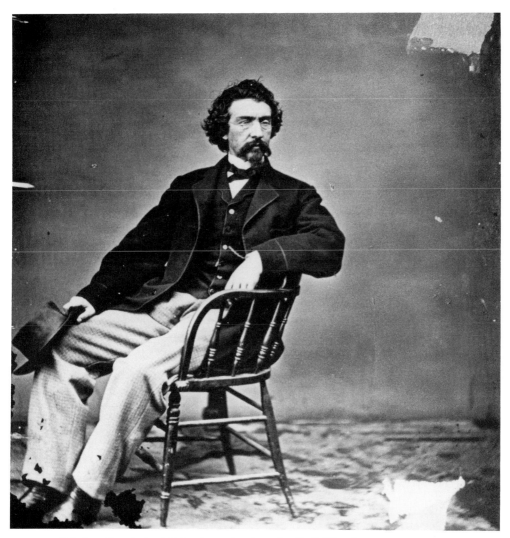

Mathew Brady in 1861, about the time the Civil War began.

The Civil War also sharply increased the demand for card photographs depicting military leaders. For example, the fall of Fort Sumter to Confederate forces made a popular hero of Maj. Robert Anderson, who had commanded the fort. Orders for card photographs picturing the major poured in. As other generals and naval officers became famous, thousands upon thousands of Americans sought their likenesses. Only

Brady, who had entered into an agreement with the Anthonys in New York to mass-produce the little cards, could supply the demand.

But for Brady there was no excitement or challenge in producing studio photographs. After all, he looked upon himself as the photographic historian of the times. He felt his role was to record what was happening, to photograph the war. As he said, "A spirit in my feet said, 'Go!' and I went."

Brady had no intention of producing a mere handful of war images. His goal was to make a complete record of the conflict's "prominent incidents." That meant covering the war on every front, battle by battle.

Taking photographs of a war was not exactly a new idea. A few daguerreotypes had been made picturing troops in the war between the United States and Mexico, from 1846 to 1848. And Roger Fenton, an English daguerreotypist, took some striking war pictures during the Crimean War in 1855.

To take pictures in the field, Brady and other photographers of the day required what amounted to a portable darkroom. It took the form of a horse-drawn wagon with a hooded, light-tight canopy. The wagon had built-in containers for chemicals, and shelves and compartments for the cameras, lenses, and other supplies and equipment.

At the same time Brady was busy getting his equipment ready, Gen. Irvin McDowell, commander of the Union forces, was preparing to obey orders that had come down from President Lincoln to attack a Confederate army under Gen. Pierce G. T. Beauregard that was encamped about thirty miles south and west of Washington along a slow-moving creek called Bull Run.

General McDowell was not eager for battle. He realized he needed time to train the 30,000 raw recruits under his command, young men who had rushed to Washington to defend the city when Lincoln had issued a call for volunteers. But the North was hungry for a quick victory. "Forward to Richmond!" (the Confederate capital) cried the New York *Tribune*.

Brady's card photographs of Northern military leaders were ordered in huge quantities by the general public. This is a page from a sample book of pictures available at Brady's Washington gallery. Maj. Robert Anderson is pictured in the top row, center.

On July 18, 1861, General McDowell led his ragtag army out of Washington, over the Long Bridge crossing the Potomac and into Virginia. His goal was to rout the Confederates, capture Manassas Junction, an important railroad junction, then continue to Richmond and points in the South. With any kind of luck, the war would be over in three months.

Many Washingtonians followed behind the troops. Everyone was bursting with confidence, certain the Confederates were going to be quickly and soundly beaten. The people, on horseback and in carriages, some with picnic lunches, thought the battle would be fun to see, sort of like an afternoon in the park with fireworks.

For Brady, this was an opportunity for which he had been waiting.

Each team of Civil War photographers traveled with a horse-drawn wagon, which carried their equipment and served as a portable darkroom.

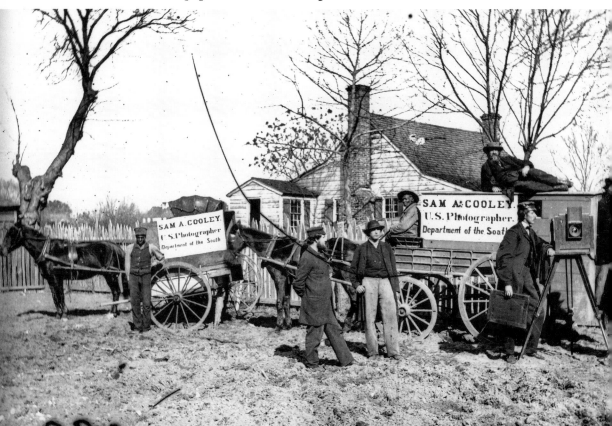

He set out for the battlefield in a specially equipped wagon. A newspaper reporter and a sketch artist, employed to create drawings for use in newspapers and magazines, went with him.

General Beauregard was waiting for McDowell's forces. Not only had Southern spies kept Beauregard informed of what McDowell was planning to do, but the newspapers also reported his intentions.

Beauregard placed his 20,000 troops along the south bank of Bull Run, the creek north of Manassas. Another 12,000 Southern soldiers, commanded by Gen. Joseph E. Johnston, were camped in the southern end of the Shenandoah Valley. These troops traveled by rail to join Beauregard on the eve of the battle, a move that brought the size of the two opposing armies into balance.

On July 21, a hot Sunday, McDowell's troops began hammering away at the Southern line. One assault followed another. The Union forces might have broken through the Southern lines had it not been for Brig. Gen. Thomas J. Jackson, who urged his regiments to stand their ground. From that day on, the general was known as "Stonewall."

The Northern soldiers had no leader to match Jackson's tenacity. When the Southerners counterattacked, the Northern line broke. At first it was an orderly retreat, but without proper training in the tactics of withdrawal, it became a stampede. The Northerners fled to the road leading to the Long Bridge and the safety of Washington.

Brady was caught up in the frenzy. It is said that he took pictures of the fleeing soldiers and civilians. In the turmoil, Brady's wagon was overturned and its contents smashed. Brady managed to salvage a few of the precious glass plates, which had been protected by the stout wooden box in which they had been stored, but no Bull Run battle photographs of Brady's have ever been seen.

Like many others, Brady took refuge in a thickly wooded area adjacent to the battle site. He wandered about, carrying the glass plates he had rescued. When he happened to run into a company of volunteers from New York, they gave him a sword to protect himself.

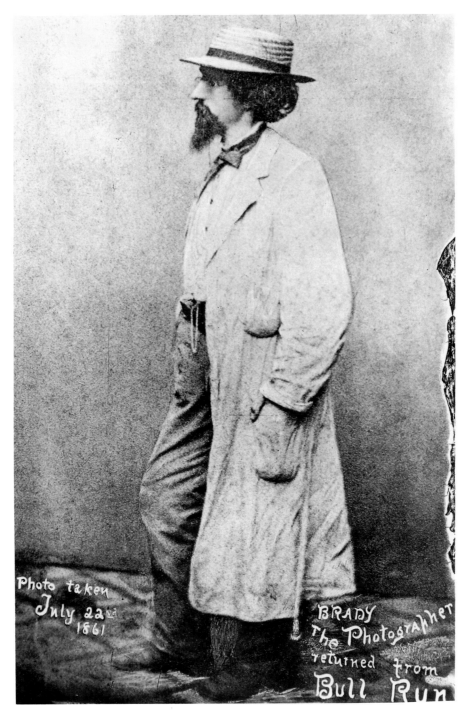

Photo taken
July 22nd
1861

BRADY
The Photographer
returned from
Bull Run

After the Battle of Bull Run, Brady posed for this photograph.

Brady managed to get back to Washington the next day. One of the first things he did on his return was to have his own picture taken. He wore his field costume, a broad-brimmed hat and a white linen duster for the photograph. Beneath the duster, one can make out the outline of the scabbard of the sword he had been given.

In the First Battle of Bull Run (also known as the First Battle of Manassas), 868 were killed and 2,583 wounded on both sides. It was not a big battle when compared to some of the engagements that were to follow, but it was the largest and bloodiest in American history up to that time.

Northerners were stunned by the defeat. There was a sudden realization that the war was not going to be over in three months or even six, that it was going to be a very long struggle.

Despite Brady's lack of success at Bull Run, the media glamorized what had happened. Said *Humphrey's Journal*: "Brady has shown more pluck than many of the officers and soldiers who were in the fight. He went . . . with his sleeves tucked up and his big camera directed upon every point of interest on the field. Some pretend, indeed, that it was the mysterious and formidable-looking instrument that produced the panic! The runaways, it is said, mistook it for the great steam gun discharging 500 balls a minute, and immediately took to their heels when they got within its focus."

While his efforts to cover the Battle of Bull Run had failed, Brady had no thought of giving up. Early in 1862, he assigned one of the operators in his Washington studio, the twenty-one-year-old Irish immigrant named Timothy O'Sullivan, to travel to South Carolina to cover Northern efforts to secure naval bases in and around Port Royal Sound. The thrust was part of the Union's strategy to seal off Southern ports, preventing all ships from entering or leaving.

At first, the vessels used by the North to enforce the blockade had only Hampton Roads, Virginia, and Key West, Florida, as bases for the

operation. That meant that some ships often had to steam many hundreds of miles for repairs and supplies. To solve the problem, the North launched the campaign of attacking small Southern harbors where bases could be established for these ships. Port Royal was one such harbor.

As part of the campaign, Brig. Gen. Thomas W. Sherman led an expedition into South Carolina with the goal of overcoming Confederate forces at such strongholds as Port Royal, Hilton Head, and Beaufort in South Carolina, and Fort Pulaski, Georgia. Fort Pulaski fell to General Sherman on April 11, 1862.

O'Sullivan's photographs depicted scenes that were recorded after the fighting had ended. They were later published by Brady and bore such titles as "Building a Pontoon Bridge at Beaufort, S.C.," "Graves of Soldiers Killed at Bombardment, Hilton Head, S.C.," and "Ruins of Fort Pulaski, Ga."

This was a significant time in the development of photographic coverage of the Civil War. Brady's wish to record "prominent incidents" of the Civil War was not being entirely fulfilled.

He realized by now that it was impossible for him to cover the war by himself. He would have to hire others to do the actual picture taking, as he had done with Timothy O'Sullivan.

Brady began organizing two-man teams of photographers he planned to send into the field. It was no easy job recruiting the men he needed, many of whom were well aware of the hardships of living out in all kinds of weather, not to mention the shellfire, random bullets, and other hazards of the battlefield.

Yet at one time or another during the war, virtually all of the most talented photographers of the day would be employed by Brady. These included, besides O'Sullivan, who has been called the best of the Civil War photographers, Alexander Gardner and his brother, James, George Barnard, James Gibson, David Knox, William Pywell, David Woodbury, John Wood, and Guy Fowx.

7

Antietam: America's Bloodiest Day

While Mathew Brady and Alexander Gardner are the best known of the Civil War photographers, there were hundreds of others who produced tens of thousands of pictures related to the conflict. The Civil War has been called, in fact, the first "living room" war. Those at home became familiar with its images through mass-produced card photographs and stereo views.

The photographic record of the war is far from complete, however. Most photographers did not travel, but simply covered events that were within easy reach. In the South, there was scarcely any war coverage at all. Southern photographers lacked the equipment and supplies necessary for picture taking.

The general public also became familiar with images depicting battle scenes and military leaders through the popular illustrated weekly magazines of the day, publications that played somewhat the same role then

as such magazines as *Newsweek* and *People* have today. The first of these, *Frank Leslie's Illustrated Newspaper*, was established in 1855. *Harper's Weekly* followed in 1857 and the *New York Illustrated News* in 1859.

Today, printing techniques enable photographs to be produced directly onto the pages of magazines, newspapers, or books. The technology to do this dates to the 1880s. Before that time, printed publications relied on artists or illustrators for their pictures. The scenes or portraits they sketched were traced by engravers onto blocks of wood for printing.

With the introduction of photography, the print media had another source for their images. A photograph would first be traced onto the surface of a wood printing block. Then the block would be carved freehand by an engraver, creating a surface that could be used for printing. It was slow, laborious work. But once the woodcut was made, it could be used to print countless reproductions. A credit line accompanied each picture.

Brady realized the value of such credit lines, and began supplying the illustrated magazines with war photographs on a regular basis. In this way, Brady's name was constantly being flashed before the public.

Civil War photographs have been called the most vivid and moving war photographs ever taken. They are all the more remarkable when one considers the difficulties photographers faced.

First of all, the exposure time necessary for photography did not enable the camera operators to photograph movement. Even a simple hand wave resulted in a blur. Fast action—a person running, a horse at full gallop—could not be captured at all.

So it was that Civil War photographers concentrated on making portraits of foot soldiers and generals. They took pictures of fortifications and equipment, war councils and prisons, and hospitals and the wounded.

The images that came to have the greatest impact are those that depicted the battlefield dead. Once the fighting had stopped, Northern

and Southern commanding officers would frequently agree to a temporary truce, a period during which the dead could be buried. During these intervals, photographers could roam the battlefield and make the pictures they wanted—if not sickened by the sight of young corpses or the stench of rotting flesh.

Besides the long exposure time, field photographers also had to struggle with the necessity of processing their photographs inside a covered wagon. The chemical mixture had to be exactly right. Any plate that became too wet or wasn't wet enough wouldn't do. In the summer, the wagon became like an oven inside, the heat made worse by the flame needed to dry the surface of the plate during the developing stage. Both summer and winter, the wagon's interior reeked of collodian and other chemicals.

Mathew Brady had no wish to put up with such conditions. He knew, of course, he did not have to go into battle zones and wield a camera himself to be the photographic record-keeper of the Civil War. He could hire operators to make photographs which he would then distribute. Brady's experience at Bull Run may have reinforced his belief that his role should be more that of a publisher than a photographer.

Brady decided to move to Washington and direct his staff of field operators from there. But once he was on the scene, friction developed between Brady and Alexander Gardner. With two managers, there was one too many.

The two men disagreed over basic policy. Brady wanted to appeal to the wealthy and privileged. He wanted the gallery to concentrate on the profitable Imperial photographs. Gardner was an astute businessman who took a mass-market approach toward photography. He sought to produce card photographs by the tens of thousands to meet the public's demand for the small cardboard rectangles.

During the last days of summer in 1862, Gardner put aside whatever problems he may have been having with Brady to cover what would come to be known by Northerners as the Battle of Antietam, and by

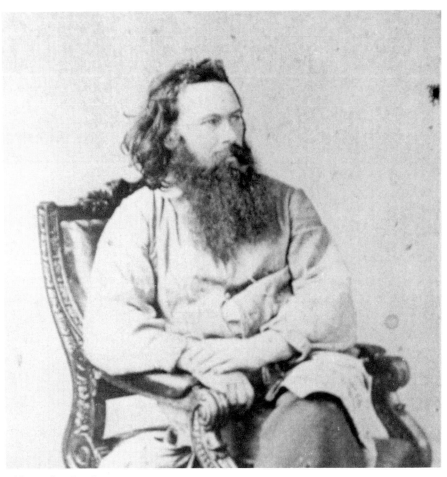

Alexander Gardner supervised Brady's Washington gallery, but split with him in 1862.

Southerners as the Battle of Sharpsburg. It began to unfold earlier in the summer at Manassas, where a Southern army had attacked and overwhelmed Northern forces a second time.

Gen. Robert E. Lee commanded the army of northern Virginia at the time. Lee moved boldly to follow up the Southern victory, carrying the war across the Potomac and into Maryland, penetrating the North. Lee reasoned that his strategy might bring Maryland into the Confed-

eracy. He also believed that with a victory in the North, he might be able to entice France or England to enter the war on the side of the South. Foreign aid from any source would be most welcome.

On September 9, 1862, Lee's forces captured Frederick, Maryland. He then divided his army, sending Gen. "Stonewall" Jackson to capture Harper's Ferry, while Gen. James Longstreet moved against Hagerstown, Maryland. Lee's goal was to win control of the Shenandoah Valley, which had important strategic value.

Gen. George B. McClellan, commanding an army of some 90,000 men, set out in pursuit of Lee. On September 13, a Union soldier found a copy of Lee's battle plan wrapped around three cigars at what had been a Southern campsite. But even with this information, the ever-cautious McClellan took no decisive action.

Lee took up a defensive position at Sharpsburg, a town on Antietam Creek in Maryland. Although McClellan commanded an army at least twice the size of Lee's, he was slow to attack. The delay was significant, for it gave the Southern armies time to join together once more, following Jackson's victory at Harper's Ferry.

At dawn on Wednesday, September 17, 1862, McClellan began a series of random attacks against the Southern lines. Lee managed to hold his ground by shifting his forces from one spot to another. At Bloody Lane, Dunkard Church, East Wood, and other such sites, the fighting was the most savage of the war, with a sickening number of losses on both sides.

After some twelve hours of fighting, Lee began to give ground, and an awesome defeat loomed. But at the crucial moment, Gen. Ambrose Pierce Hills' forces arrived from Harper's Ferry, enabling Lee to attack and push the Northern line back. Soon after, darkness fell, ending what would come to be known as "America's Bloodiest Day."

On that one day of fighting at Antietam, September 17, 1862, more than 26,000 were killed, wounded, or listed as missing. In no other day in history were so many American casualties recorded. As historian Wil-

liam Frassanito has pointed out, on World War II's D-Day, June 6, 1944, when the Allies launched a massive invasion of France from England, losses totaled 6,700.

The most memorable photographs from Antietam were made by Alexander Gardner and James Gibson. A Gardner image, titled "View of the Battle-field of Antietam on day of battle, Sept. 17, 1862," is one of the very few Civil War photographs to depict actual combat. The photograph was taken from a ridge overlooking the field of battle. In

Alexander Gardner's historic photograph of the battlefield at Antietam.

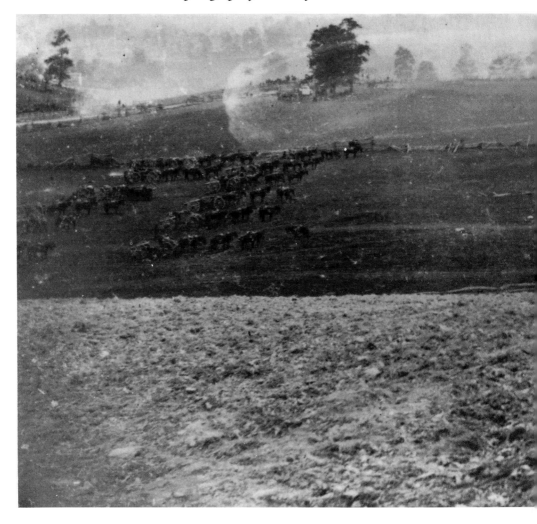

the foreground sits a man with field glasses that are trained upon the action. To the left, scores of horse-drawn ammunition wagons—called caissons—are massed. The battle rages to the right and gunsmoke drifts over much of the scene.

Within hours after the Southern troops began their withdrawal, Gardner and Gibson began making photographs of what the struggle had wrought. They photographed dead soldiers along Hagerstown Pike, Bloody Lane, and Antietam Bridge. They also made photographs of

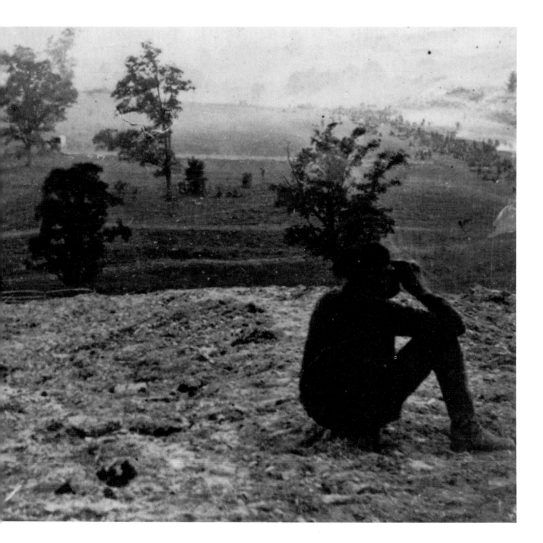

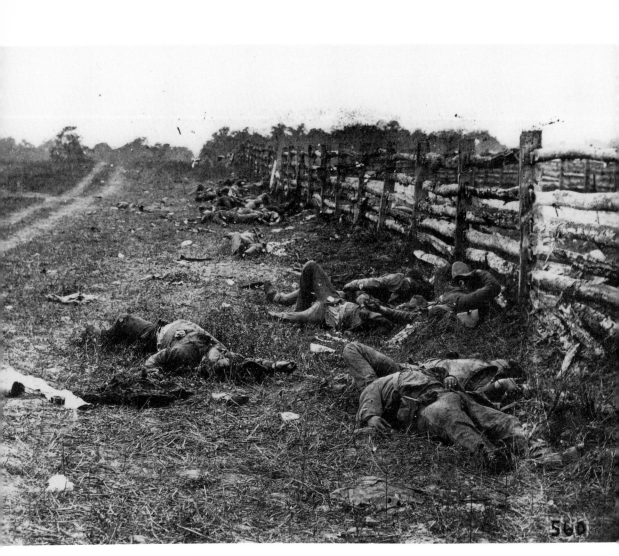

Following the Battle of Antietam, Gardner took this photograph of Confederate dead along the Hagerstown Pike.

General McClellan's camp near Sharpsburg. In all, some seventy photographs were taken by Gardner and Gibson.

Brady put many of these photographs on display in his gallery in New York. The *New York Times* noted: "Mr. Brady had done something to bring home to us the terrible reality and earnestness of war. If he has

not brought bodies and laid them in our dooryards and along streets, he has done something very like it."

The photographs inspired Oliver Wendell Holmes, writing in the *Atlantic Monthly* in July, 1863, to say: "Let him who wants to know what war is, look at this series of illustrations."

In 1862, Brady published two collections of the choicest war photographs available to him. One was titled *Brady's Photographic Views of the War*, the other *Incidents of the War*. Both consisted of actual photographs that had been mounted on album pages. The Antietam photographs of Alexander Gardner and James Gibson were first offered to the public in these collections.

In November, 1862, when the Anthony company of New York, the firm that marketed Brady's photographs, issued a sixteen-page "Catalogue of Card Photographs," nineteen of the Gardner-Gibson images from Antietam were included. Small card photographs of the images could be purchased for as little as twenty-five cents.

Gardner no doubt became embittered because all of the Antietam photographs bore the printed line: "Photo by Brady." In other words, neither Gardner nor Gibson received any recognition from Brady for their fine work.

Sometime after the Battle of Antietam, Gardner left Brady and accepted an assignment as the official photographer for Gen. George B. McClellan, commander of the mighty Army of the Potomac. Gardner was given the honorary rank of captain.

But Gardner's military service was very brief. When General McClellan was temporarily relieved of his command later in the fall of 1862, Gardner left the army to open his own studio in Washington. His brother, James, joined him in the venture. For photographers, Gardner hired two of Brady's best—Timothy O'Sullivan and Guy Fowx. The loss of Gardner as manager of his Washington studio was to prove very damaging to Brady, contributing to the hard times that later were to plague him.

8

The War Years

After his split with Alexander Gardner, Brady turned over the operation of his Washington studio to photographer James Gibson. Brady and his wife, Julia, continued to live in Washington. The expense of employing photographers to cover the war was beginning to be a heavy financial drain, but Brady struggled along, dipping into his savings to support the venture. He continued to operate his studio at Broadway and Tenth Street in New York. There business continued at a brisk pace.

Early in 1863, with the North still agonizing over a disasterous defeat at Fredricksburg for the Army of the Potomac, Brady became deeply involved in an unusual event that pushed the Civil War off the front pages of the daily newspapers. It was the wedding of two midgets that took place at Grace Church in New York, near Brady's studio on Broadway.

The groom was General Tom Thumb, now twenty-five years old but only 38 inches in height. The bride was twenty-one-year-old Lavinia Warren, who was about an inch shorter than the general.

The extraordinary event was sponsored by P.T. Barnum, the greatest showman of the day. The bride and groom were among Barnum's top money-makers. He saw their marriage as an opportunity to draw even more customers into his museum. As the wedding date drew near, as many as 20,000 people a day paid to visit the museum and view Lavinia and her engagement ring.

On the day of the wedding, Grace Church was filled to overflowing. Crowds of people jammed the streets outside. Police were hardly able to control the throng.

Barnum had named Brady to be the official wedding photographer. Brady saw to it that the bride and groom were photographed in scale, so that their smallness was apparent.

Card photographs of the couple and other members of the wedding party, produced in quantity by Anthony & Company from Brady's negatives, were all-time bestsellers. Even today, the small cards, available from dealers in antique photographs, are sought by collectors.

On their wedding trip, the Thumbs visited Philadelphia and Washington. The Lincolns gave a reception for them at the White House. Tad Lincoln, who could scarcely take his eyes off the couple, remarked, "Isn't it funny that Father is so tall and Mr. and Mrs. Thumb are so little?" Lincoln overheard his son's comment and said, "My boy, God likes to do funny things. Here you have the long and short of it."

Sometime after the wedding, the Brady studio produced a photograph of the Thumbs holding an infant. The photograph was captioned: GEN. TOM THUMB, WIFE & CHILD. The picture sold by the thousands as a card photograph. The photograph was one of Barnum's hoaxes, performed for publicity's sake. The infant in the picture was borrowed. The Thumbs never had children.

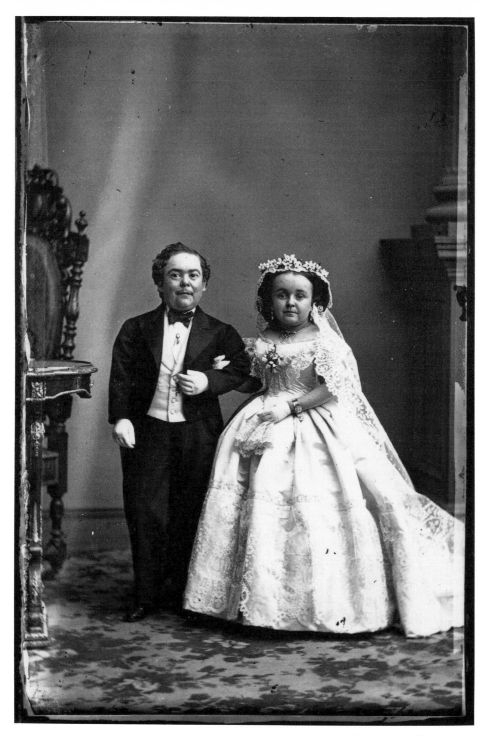

The highly publicized wedding of two midgets, General Tom Thumb and Lavinia Warren, at Grace Church in New York in the spring of 1863 crowded the Civil War off the front pages of the daily newspapers. This is one of Brady's photos.

LATE IN JUNE, 1863, following what was a costly victory over Union forces at Chancellorsville, Virginia, General Lee laid plans to invade the North again. This time the Southerners swung through Virginia's Shenandoah Valley into Pennsylvania. Lee commanded an army of 65,000 men, many of whom suffered from a lack of equipment. In fact, as many as half of Lee's soldiers marched barefooted.

Two Confederate divisions, about 30,000 men, split off from the main body of troops and veered east toward Gettysburg. The little town was important as a road junction. It also had a shoe factory.

On July 1, 1863, on the outskirts of Gettysburg, the Southerners ran into Union cavalry units, mounted soldiers who were the advance elements of the Army of the Potomac, now under the command of the hot-tempered Gen. George C. Meade. Fighting raged throughout the day, with the edge going to the Southerners. Northern troops were pushed back into the hills south of the town.

For the next two days, Lee ordered his forces to attack the Northern positions, but with little success. He felt his only hope of victory was to launch an all-out assault against Cemetery Ridge, which represented the very center of the Union line.

On the hot and humid afternoon of July 3, Lee sent about 13,000 men under Gen. George E. Pickett to attack the Union position. The Southerners advanced in precise parade formation, which was still military custom. As they marched across an open field and up the slopes of Cemetery Ridge, the Northerners opened fire with artillery shells and rifles. "Pickett's charge," as it was called, was a massacre. Only a handful of Southern troops managed to reach the top of the ridge and they were either killed or taken captive. Thousands died in the assault. Barely one-half of the Southern forces managed to return to Southern lines.

On the evening of the Fourth of July, in a torrential downpour, Lee, who took full responsibility for ordering the head-on attack, withdrew his battered army back to Virginia. General Meade, judging his men to be too weary, made almost no effort to pursue. For this, he was loudly

criticized. Both armies suffered dreadful losses at Gettysburg. One third of Lee's army had been killed or wounded. Never again would Lee attempt to trespass north beyond the Potomac River.

On July 3, the day of Pickett's charge, news of the great battle at Gettysburg reached Alexander Gardner in Washington. He packed up his equipment and left immediately for the battlefield. Timothy O'Sullivan and James Gibson went with him.

On the morning of July 5, one of Lee's retreating generals, J. E. B. Stuart, and his calvary force entered the town of Emmitsburg, Maryland, just south of the Pennsylvania border, where his men captured a number of Northern soldiers. They also captured Alexander Gardner, but released him within a few hours. Gardner later published a photograph, the caption for which read: "Farmers' Inn and Hotel, Emmitsburg, where our special artist was captured, July 5th, 1863."

Gardner, O'Sullivan, and Gibson reached the battlefield on the afternoon of July 5, and started taking photographs almost immediately. The three men concentrated on "death views"—dead bodies and graves. By July 6, most of the dead had been buried, and Gardner and the others began photographing battlefield fortifications and other remnants of the struggle. The next day they moved on to the town of Gettysburg itself.

Gardner was delighted that he had beaten Brady to the punch. Not until about a week after Gardner had returned to Washington did Brady and his cameramen arrive at Gettysburg.

While he was tardy in getting to Gettysburg, Brady was able to take advantage of the fact that the landmarks of the battle were well known by the time he arrived. There were even guides on hand to point out and explain the features of the battle to visitors.

Brady or his assistants photographed Lee's headquarters, McPherson's Woods, Little Round Top, the Lutheran Seminary, and other such images, all of which had taken on historical importance. While Brady's photographs taken at Gettysburg lacked the impact of the death views made by Gardner, O'Sullivan, and Gibson, they proved to be

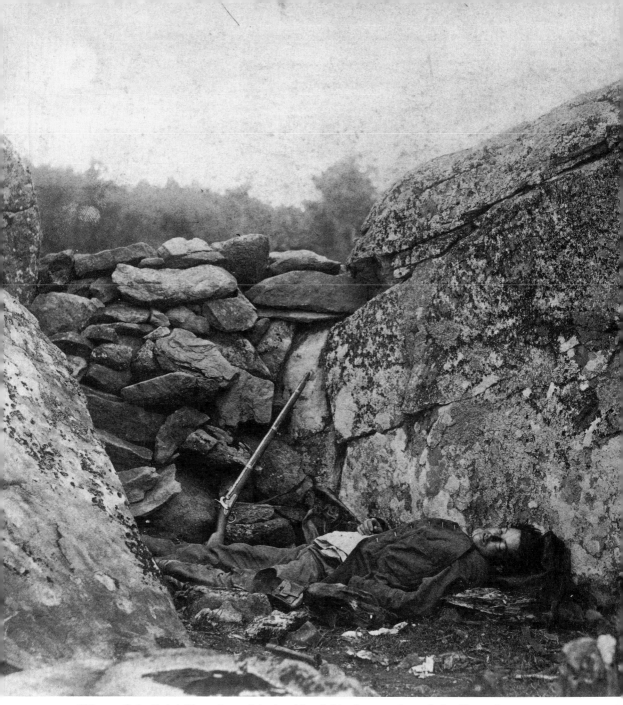

"Home of the Rebel Sharpshooter" is the title of this photograph made by Alexander Gardner at Gettysburg in July, 1863, with the assistance of Timothy O'Sullivan.

extremely popular and, as engravings, were copied and circulated by newspapers and magazines of the day. *Harper's Weekly* devoted its issue of August 27, 1863, to Brady's battlefield coverage.

EARLY IN 1864, it was rumored that Gen. Ulysses S. Grant, the hero of a stunning Union victory at Vicksburg, Mississippi, was to be named general in charge of all the Union armies. "Grant is my man!" Lincoln had said, "and I am his the rest of the war."

The president summoned Grant to Washington to announce his appointment and award him the three stars of a lieutenant general. When the news leaked that Grant was on his way to Washington, *Leslie's* and *Harper's* sent telegrams to Brady asking for pictures.

What pictures were available weren't suitable, Brady decided, so he made up his mind to have new ones taken. On March 8, 1864, when Grant's train rolled into Washington, Brady was waiting at the station. He introduced himself to the general, told of his need for photographs, and got him to promise to come to the studio for a sitting.

Grant received his commission from the president the next day, and afterward went to Brady's studio. He was accompanied by Secretary of War Edwin M. Stanton.

Brady had three cameras ready in the operating room. When the general was suitably posed and the photographers were about to shoot, a passing cloud dimmed the light from the skylights. Brady sent an assistant up to the roof to draw back mats which partially covered the skylights. As he was carrying out this task, the assistant slipped and his foot plunged through the skylight, sending splinters of glass flying down close to Grant.

Grant hardly noticed what had happened but Stanton gasped. He pulled Brady aside and whispered that he was not to breathe a word of the incident. Stanton explained that if word got out of what had happened, the public might think a plot had been formed to assassinate the general.

One of the photographs of Gen. Ulysses S. Grant taken at Brady's studio on March 9, 1863.

Brady promised to say nothing of the incident and went back to getting the photos taken. The pictures that resulted, perhaps the best ever taken of Grant, show a serious man, carefully groomed, somewhat youngish in appearance, before the war's stresses were etched upon his face.

ONCE IN COMMAND of the Union armies, Grant developed a simple battle plan. His forces would attack everywhere. Not only would Southern armies be the target of the North, but Grant's forces would also lay seige to supply depots, railroad centers, and the South's principal cities.

By this time, the early months of 1864, all signs seemed to point to an eventual victory for the North. The size of the Southern armies had shrunk because of battle losses and supplies dwindling. But the South had no thought of giving up, and the bitter fighting was to continue for another year.

Photographic coverage of the war was now common. For example, when Grant ordered Gen. William T. Sherman and his army of 100,000 men to march from Chattanooga, Tennessee, to Atlanta, Georgia, a campaign that lasted four months, George Bernard, who had once worked for Brady, went along as an Army photographer.

Northern military leaders now recognized the value of photographs as aids to mapmakers and construction engineers. Several photographers were given "official" status with Northern armies. The most noted was Capt. Andrew J. Russell, whose wartime duties included recording the activities of the Railroad Corps as it transported Northern troops through Virginia. Russell and his camera also covered the fighting at Fredericksburg, Petersburg, and Brandy Station. Many of Russell's photographs were attributed to Brady until fairly recent times.

After the Civil War, Josephine Cobb, at one time the archivist-in-charge of the Still Picture Branch of the National Archives, compiled a list of some 300 photographers and gallery owners who received special passes from military authorities to photograph one phase or another of

Brady, in the center of the photograph, wearing a straw hat, during a visit to an artillery battery outside Petersburg, Virginia, in June, 1864.

the war. Compare this attitude with the tight controls the Department of Defense imposed upon journalists during Operation Desert Storm in 1991. Few reporters or camera crews ever got to the scene of the actual fighting.

In May, 1864, the armies of Grant and Lee clashed in a desolate area

Brady's photography wagon in a wooded area near Petersburg, Virginia, in 1864.

of northern Virginia called the Wilderness. Both sides suffered heavy losses and neither could claim a clear victory. Shortly after, at Spotsylvania, a few miles from the Wilderness, the two armies again came face to face and again both took heavy losses.

On June 1, 1864, Grant's army reached Cold Harbor, just north of the Confederate capital of Richmond. Grant then ordered a frontal assault against Lee. In the first two hours of fighting, some 7,000 Northern troops were cut down.

In a month, Grant had lost 55,000 men and cries of anguish were coming from every part of the North. "Butcher" Grant, he was being called. But Grant would not relent. He took his army across the James River and advanced toward Petersburg, a vital rail center south of Richmond. When Grant realized he could not capture Petersburg in a single thrust, he ordered his men to dig and occupy trenches around the city. Grant's bitter siege was to last nine months.

On June 21, 1864, Brady and an assistant arrived at Petersburg in a darkroom wagon. Brady climbed down from the wagon and approached Capt. James Cooper, who commanded a battery of light artillery, and asked permission to take a picture. Captain Cooper said yes.

After Brady and his assistant had set up their big camera on a tripod, and Brady began to focus, Captain Cooper, to make the photograph as lifelike as possible, gave the command to load and fire. His gunners immediately began to run to their positions.

Southern batteries, positioned only a few hundred yards away, took note of the activity and, not realizing the Northerners were merely play-acting, opened fire. Shells began exploding all around Cooper's battery. Brady's horse bolted and fled across the field, scattering plates and chemicals while the driver strained at the reins. Brady, remaining calm, took several more pictures.

Captain Cooper withheld his fire and the enemy guns were soon silent again. Before leaving the scene, Brady took a position amidst

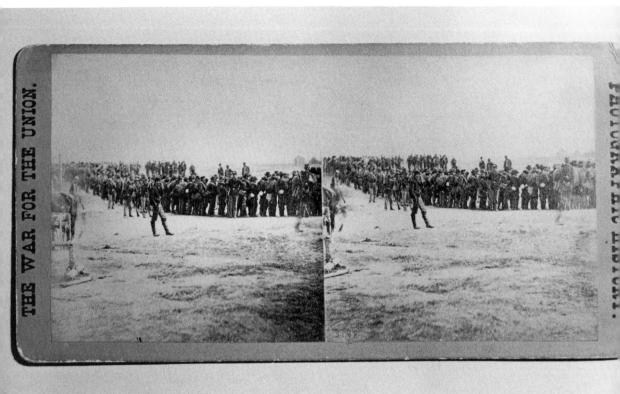

A stereo card depicting Southern prisoners captured at Five Forks, Virginia, on April 2, 1865. On the reverse side, the card notes: "These are the original views taken by Brady, the Government Artist . . ."

Cooper's guns and gunners and instructed his assistant to take another picture, a souvenir of what was Brady's closest call of the war.

In the final year of the war, Brady and the photographers who worked for him covered fewer and fewer of the war's "prominent incidents." The reason was money. Beginning in 1864, Brady began to have serious financial problems.

The loss of Alexander Gardner as the manager of his Washington studio had been a heavy blow. Gardner's replacement, James Gibson, was a skilled photographer, but he lacked Gardner's ability as a businessman, and the operation was no longer profitable.

Brady was often unable to support operations in the field. In their book, *Mathew Brady and His World*, Philip Kunhardt and Dorothy Meserve Kunhardt tell of David Woodbury, a young photographer who greatly admired Brady and worked diligently for him through most of the war. However, Brady all but abandoned poor Woodbury, failing to send him the supplies he required. Woodbury, like other of Brady's battlefield photographers, finally quit in frustration and disgust.

Brady and his wife eventually returned to New York and he sought to manage his troubled business affairs from there. He had used some $100,000 of his savings to purchase plates, chemicals, and other supplies for himself and his photographers, and he had nothing left. He had expected the sale of card photographs and stereo views would produce enough money to pull him out of debt, but while the war pictures sold well at first, they were never as profitable as he had hoped they would be, and once the war was over, people would want to forget it, and there would be scarcely any market at all for the photographs.

With his money gone, Brady had depended on credit. Now his creditors were clamoring to be paid.

9

Aftermath

During the winter of 1864–65, sickness, disease, and desertions cut deeply into the Southern ranks. Food was in very short supply and those Southern soldiers who did remain at their posts barely had enough to eat.

General Grant achieved his goal in the spring, seizing Petersburg and then forcing the Confederate government to abandon Richmond. Soon after, Lee realized that to continue fighting would mean the needless loss of more lives. On April 9, 1865, Lee surrendered to Grant at Appomattox Court House, Virginia. The long struggle was finally over.

Brady was at Petersburg, photographing Southern fortifications, when he heard the news of the surrender. He and an assistant left immediately for Appomattox Court House, but arrived too late for the historic meeting. Brady may have, however, gotten some consolation

from the fact that no other photographer managed to record the event, either.

After Appomattox, Brady headed for Richmond. Confederate troops had burned the city before they abandoned it, and Brady or his cameraman made some dramatic pictures of the widespread devastation.

Brady's next goal was to photograph General Lee. He went to Lee's home in Richmond. At first, the general refused to pose, but he eventually yielded to Brady's pleas. Brady photographed the general seated and standing, and with his son, Gen. Custis Lee, and his young chief of staff, Col. Walter Taylor. Brady's photographs are the most famous ever made of the general.

Many years later, Brady was asked who helped in arranging the portraits of Lee. "Robert Ould and Mrs. Lee," he replied. "It was supposed that after his defeat it would be preposterous to ask him to sit, but I thought that to be the time for the historical picture. He allowed me to come to his house and photograph him on the back porch in several situations. Of course, I had known him since the Mexican War and when he was upon Gen. Scott's staff, and my request was not as from an intruder."

Five days after Lee's surrender at Appomattox Court House, Lincoln was shot and killed by John Wilkes Booth, a noted actor of the day and a fanatical supporter of the Southern cause. The nation was shocked and saddened.

After the shooting, Booth fled on horseback across the Potomac. Soldiers picked up his trail and trapped him in a tobacco shed outside Port Royal, Virginia. The wood structure was set afire. A shot rang out and Booth fell. Boston Corbett, a sergeant in the Union Army, said he fired the bullet that killed Booth. A week or so later, Corbett was photographed at Brady's Washington studio.

On May 24, 1865, the Grand Review of the Union Armies, the military salute to the Northern victory, got underway in Washington.

One of Brady's famous photographs of Gen. Robert E. Lee, taken after Lee's surrender at Appomattox Court House. Lee's son. Gen. Custis Lee, is at his left; his chief of staff, Col. Walter Taylor, is at his right.

Brady, working with his assistants, covered the event. One of the Brady cameras looked down at the marching troops from a vantage point above Pennsylvania Avenue, with the Capitol in the background. A striking photograph of the event resulted.

Despite this activity on Brady's part, he no longer was Washington's leading photographer. Alexander Gardner was. It was Gardner who photographed the most important events of the day and the noted political leaders. It was Gardner who had taken the last portrait photos of President Lincoln. And not long after the assassination, Lincoln's successor, Andrew Johnson, posed for Gardner at his studio.

Johnson's portrait, credited to Gardner, appeared as an engraving in *Harper's Weekly* on May 13, 1865. Gardner's card photographs depicting the new president were soon available to the public.

When the conspirators in Lincoln's assassination were captured, Gardner photographed each of them. It was also Gardner who received permission to make a series of photographs that showed four of the conspirators being fitted for the gallows rope and hanged.

Meanwhile, Brady's gallery operation in Washington continued to edge downhill. He became involved in one legal action after another as creditors sought to collect the money due them. By 1868, Brady's studio was so deeply in debt that Brady was forced to declare bankruptcy, meaning the gallery and whatever property he owned were to be sold at auction, with the money derived from the sale going to his creditors.

When the gallery was put on the auction block, Brady himself was the only bidder. He managed to scrape together $7,600 and was able to gain ownership again.

Although Brady spent much of his time battling creditors, he also continued to add to his collection of Civil War images. During the war, Brady had exchanged negatives with other photographers or borrowed negatives and copied them. If a photographer happened to take duplicate photos of a scene, or used more than one camera in recording it, Brady would seek to get his second-best image. It is also likely that Brady

purchased negatives in bulk quantities from photographers who did not want to be bothered trying to store their bulky and fragile glass plates.

In 1865, Alexander Gardner published an impressive volume that contained one hundred of the best Civil War photographs made by himself and the cameramen who had worked for him. Titled *Gardner's Photographic Sketch Book of the War*, it has been praised as the finest book of its type ever published, surpassing in quality similar volumes that had been put out by Brady.

Brady wasted little time in copying the images from Gardner's *Sketch*

Sgt. Boston Corbett, the man who claimed to have shot John Wilkes Booth, visited Brady's studio to pose for this photograph.

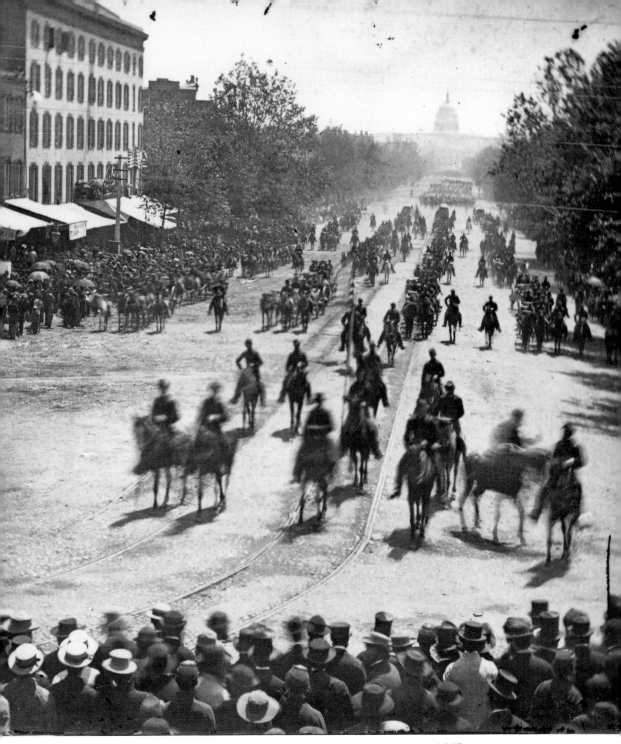

The Grand Review of the Union Armies in Washington, May 24, 1865, as photographed by Brady or one of his cameramen.

Book and adding them to his collection. Brady did the same after George Bernard published his *Photographic Views of Sherman's Campaign.*

Brady didn't care where the photographs happened to originate. He believed his Civil War collection should include every available image.

Brady was also having troublesome times in New York. His biggest creditor was Anthony & Company, which had provided him with photographic supplies on credit during the war. The firm agreed to accept a duplicate set of Brady's negatives in settlement of the debt. Anthony & Company continued to publish Brady's photographs in the years that followed, but Brady received no income from them.

Brady also had unpaid bills for clothing and rent. In 1869, he sold property he owned at Fifth Avenue and 105th Street in New York to satisfy some of his debts.

THE WORLD OF PHOTOGRAPHY was changing. Cabinet cards were replacing the small card photographs in terms of popularity. Approximately 4¼ by 6½ inches in size, cabinet cards were almost four times as large as *cartes de visite.* Cabinet cards triggered advances in lighting that made possible a greater variety of poses. Photographers also began using elaborate scenic backdrops as settings for their portraits.

Overall, portrait photography became more imaginative, more artistic. Napoleon Sarony, a Canadian-born photographer who opened a studio in New York in 1866, specialized in portraits of theatrical stars. By posing his subjects dramatically, Sarony created portraits that could almost be considered a form of entertainment.

Like Brady, Sarony functioned as a stage manager, a producer. He set up the camera, positioned the lights, reflectors, and screens, arranged the draperies and props, and posed the subject. He was called the "Napoleon of photography."

As Gardner came to overshadow Brady in Washington, so Sarony did in New York. While theatrical portraits were his specialty, Sarony also photographed government and military leaders, and notable figures

Mathew Brady was in his early fifties and beset by creditors when this photograph was taken in 1875.

in the business world. "Indeed," says Ben L. Basshan in *The Theatrical Photographs of Napoleon Sarony*, "Sarony photographed everybody who was anybody (and thousands who simply wanted to be somebody)." Virtually the same thing had been said about Brady a quarter of a century before.

Brady had always been able to ignore court orders to pay his New York debts, thanks to his friendship with "Boss" Tweed, the most powerful political leader of the time. But by 1872, Tweed's influence was waning and his friends were no longer able to protect Brady.

With assets of less than $12,000 and debts of more than $25,000, Brady was declared bankrupt again, this time in New York. But Brady was tricky. He got the sheriff of New York, a friend of Tweed's, to haul off to storage nineteen cartloads of the contents of his New York studio. He managed to do this before the court, which represented his ninety-four creditors, could lay claim to them.

At the time of the Civil War, Brady was a wealthy man and at the peak of his fame, a household name. But the war, the event with which he is so closely identified today, helped to ruin him.

Surrounded by disaster in New York, Brady left the city for Washington, where he and his wife again took up residence. Brady was in his early fifties now. Often he was bad-tempered and quarrelsome. His problems led him to often drink heavily. His world had collapsed.

10

The Final Years

In the years following the Civil War, many photographers, for adventure and opportunity, headed West, a land rich in subject matter. Easterners were curious about life on the frontier. There were breathtaking scenic views to be recorded.

In the late 1860s and during the 1870s, the federal government conducted four surveys of Western territories, each meant to explore and map the land and determine its economic potential. Photography was essential to each of the surveys. The construction of the first transcontinental railroad and the periodic conflicts with the Indians were other subjects to be covered.

Alexander Gardner closed his gallery in Washington in 1867 and went West as chief photographer for the Union Pacific Railroad, Eastern Division. Andrew Russell, Timothy O'Sullivan, and Thomas Roche, all of whom had been in the forefront in covering the Civil War, also packed

up their cameras and equipment to heed the call of the Western frontier.

But not Mathew Brady. Remaining in Washington, he continued to operate his gallery and, as a way of getting financial relief, he tried selling his collection of war views and portraits.

He first tried to interest the New York Historical Society in the collection. But the Historical Society would have had to raise money to pay for the photographs from the general public by means of a subscription fund. Although the photographs were considered a national treasure, the broad-based support necessary for the purchase could not be obtained.

In 1874, the owner of a New York warehouse where some of Brady's property was stored sought to collect by legal means money due him for the nonpayment of storage bills. He auctioned off some of Brady's war negatives to settle the claim. They finally ended up in the possession of the War Department, thanks to the concern of Secretary of War William Belknap, who authorized the payment of $2,840 for them.

The fact that the War Department had paid out money for a portion of his photographs stimulated Brady's hope that he might interest the government in buying the whole collection. In a letter to Secretary Belknap, Brady wrote: "I have spent a lifetime collecting the works I now offer; I have kept an open gallery at the Capital of the Nation for more than a quarter of a century to assist in obtaining historical portraits, and have spent time and money enough, dictated by pride and patriotism, to have made me independently wealthy. In my exertions to save the collection entire, I have impoverished myself and broken up my business and, although not commissioned by the Government to do the work I did, still I was elected by the general consent of the Officers of the Government, from the President down, to do the work."

In March, 1875, Congress acted, appropriating $25,000 to pay Brady "to secure a perfect title" to *all* of his negatives, not merely the war views. The government eventually received a total of 5,712 negatives of various sizes.

The money that Brady received energized him. He was able to pay off his debts and do some remodeling in his Washington studio. On February 4, 1877, he gave a reception at the gallery, which was attended by many representatives of official Washington, including a number of senators and members of the House of Representatives.

Many of the most notable people of the day still felt it a necessity to have their pictures taken at Brady's studio. Those photographed during this period included Susan B. Anthony, a leader in the movement to win women the right to vote; Thomas Edison, the brilliant inventor; and Salmon P. Chase, who had been Lincoln's Secretary of the Treasury and now served as Chief Justice of the Supreme Court.

And Brady's studio also continued to photograph presidents. In 1877, after Rutherford B. Hayes was inaugurated as the nineteenth president, he spent two hours posing at Brady's studio. James A. Garfield, who succeeded Hayes in 1881, was a friend of Brady's, and had his picture taken at the studio in the winter of 1880.

William McKinley, as a young congressman from Ohio, also visited Brady's studio for a portrait. McKinley became the nation's twenty-fifth president in 1897.

While there were some bright moments, these were often dismal years. Brady still faced competition in Washington. Younger, eager photographers, using new techniques, took business that, in an earlier time, might have gone to him. Brady's Washington gallery fell into tumbledown condition.

For a time, Brady and his wife lived at the National Hotel, where they had stayed in better times. When the National proved too expensive, the Bradys moved to a series of cheaper hotels and boardinghouses. They finally established living quarters in the gallery itself.

Mrs. Brady now suffered from a heart ailment and was bedridden much of the time. Brady's own health was becoming a serious problem, too. Often he was in pain from arthritis. And his poor eyesight, instead of being merely an inconvenience, was becoming a serious handicap. His

William McKinley, who became the nation's twenty-fifth president, was photographed at Brady's Washington studio as a young Congressman.

nephew, Levin Handy, had taken over most of the work involving the gallery.

In 1881, Brady sold his portraits of Daniel Webster, Henry Clay, and John C. Calhoun to the government. These were the paintings that had been made from his daguerreotypes, and which he had displayed proudly in his galleries.

The sale of the paintings did little to solve his problems. Brady was soon in serious financial trouble again. An employee of Brady's, who had not been paid, sued him in District Court. The action led to foreclosure of the mortgages on his studio property. In November, 1881, the Brady National Photographic Art Gallery at 627 Pennsylvania Avenue closed its doors for the last time.

Brady, in his sixties, continued to work in Washington, sometimes under the name of Brady & Company, other times in partnership with local photographers. In 1887, his wife, Julia, died of a heart ailment.

Lydia Mantle Fox, who maintained a secretarial service in Washington for congressmen with no office staffs of their own, remembered Brady from these years. She once described him as a "sad little man."

Brady often pestered Ms. Fox at her office with requests to prepare letters from him to any congressman who might be interested in the remaining war photos he owned. While Brady entertained her with tales of his glory days as the prince of New York photographers and his exploits during the Civil War, he also complained to her of his financial woes, his poor health, and loneliness, which had deepened since the death of his wife.

ONE DAY not long after Brady had reached his seventies, he was crossing a street in downtown Washington when he was struck by a horse-drawn streetcar, an accident that left him bleeding and unconcious. He was rushed to the hospital, where he spent several weeks recovering. Once he was released from the hospital, he had to get about on crutches.

For a time after the accident, Brady lived with his nephew and niece

BRADY'S

National Photographic Portrait

GALLERIES,

Broadway and 10th Street, New York.

627 Pennsylvania Avenue,
Washington, D. C.

*Some of the many imprints
used to identify Brady photographs.*

in Washington. In 1894 or 1895, he returned to New York, taking a small apartment at 126 East Tenth Street. It was only a five-minute walk to the location of the lavish gallery he had once operated on Broadway near Tenth Street. It was there that he had photographed Abraham Lincoln. It was also at that studio that the Prince of Wales and his royal party had visited. Every time he passed the site, Brady must have been reminded of his days of greatest fame.

Brady had not been in New York very long when he embarked on what was to be his last venture. He was a member of the Seventh Regiment in New York, and his comrades in the organization announced plans to hold a Grand Testimonial Benefit in his honor. As part of the program, Brady would entertain the guests with a stereopticon show. The stereopticon, or magic lantern, as it was called, was a method of projecting images from large glass slides onto a huge screen. A narrator commented on each slide.

The Civil War, of course, was to be the subject of Brady's talk. He set to work having the slides made from negatives and photographs that were in his nephew's possession. He also sought to rent a projector. New York's Carnegie Hall was to be the scene of the presentation. The date was set for January 30, 1896.

BRADY'S
National Photographic Portrait
GALLERIES,
Broadway and 10th Street New York.
———
627 Pennsylvania Avenue,
Washington D C.

BRADY'S
National Portrait Gallery,
625 Pennsylvania Avenue,
WASHINGTON, D. C.

But in November of 1895, Brady collapsed with a painful kidney ailment. William Riley, a devoted friend of Brady's in the last years of his life, made arrangements for him to enter New York's Presbyterian Hospital.

For a time, Brady seemed to be improving. He continued planning for the slide presentation from his hospital bed. But not long after New Year's Day, Brady's illness grew worse. On January 15, 1896, Mathew Brady died.

WILLIAM RILEY went to Brady's rooms to collect his belongings. Sadly, there was little that remained. In a letter to Brady's nephew, Reilly wrote: "I have made a thorough examination of Mr. Brady's effects, and find no papers or other property that it would pay to send you. His wardrobe was only scant, and his coats in number, two . . . an overcoat and frock coat that I gave away. The balance consists of some underwear, a few shirts and socks, etc., not of sufficent [value] to send, and so I thought I would send them to the needy.

"There is an old worthless Waltham watch and also a ring. (This is a gift from the Prince of Wales.) The latter you will, I suppose, want, and if you would want, I will send it to you.

"The satchel is old and broken and one you would not want. The papers consist mainly of old and unimportant letters which I have put in the wastepaper basket. There are no other papers of the slightest value."

Brady's body was sent to Washington for burial next to his wife in the Congressional Cemetery, a national cemetery created by the federal government and the resting site of many historical figures.

For years, a small marker over Brady's grave gave the year of his death as 1895, not 1896. The error was corrected in 1988 when a group of Civil War enthusiasts from Warren, Ohio, paid to have a new stone erected. Uncertain of the date of birth, they used CA for *circa*, meaning "about or around" 1822.

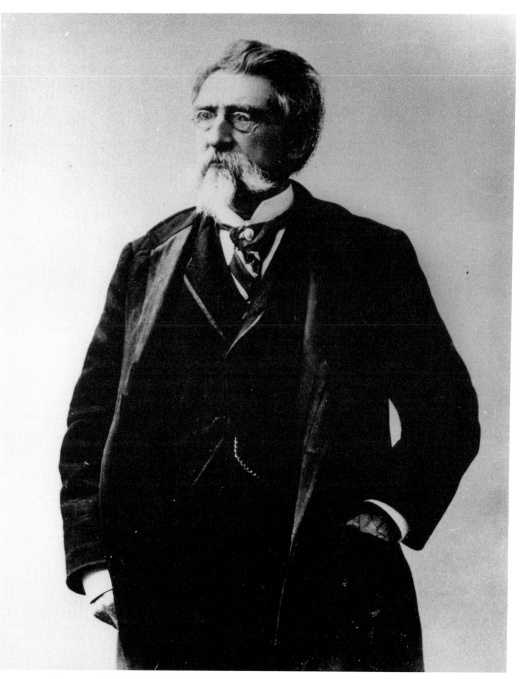

Mathew Brady in 1889 at the age of sixty-five or sixty-six in a photograph taken by his nephew.

WHILE BRADY'S ASSETS were practically nonexistent at the time of his death, his legacy included all those daguerreotypes, stereo views, card photographs, and other images that were produced by his studios in New York and Washington, many of which were sold to the general public by Anthony & Company for about a quarter of a century. The credit line, "Photograph by Brady," was known to millions.

Earlier, when Brady had been unable to pay for equipment and supplies he had purchased from Anthony & Company, he was forced to turn over some 7,000 negatives to the firm. In 1907, after having changed hands several times, these negatives were obtained by Edward B. Eaton, a Hartford, Connecticut, publisher. Eaton's Patriot Publishing Company described itself as "Publishers and Specialists in War Photographs, Sole Owners of the Famous Brady Collection of 7,000 Original Negatives Taken on the Battlefields during the Civil War."

Eaton used the negatives in the publication of several different works, the best known of which is *The Photographic History of the Civil War*, a ten-volume study published in 1911–12. After Eaton's death in 1942, the Library of Congress learned of the existence of the negatives and purchased them.

Another collection of several thousand negatives from Brady's Washington studio were inherited by Levin Handy. Upon Handy's death, the Library of Congress obtained these negatives from Handy's two daughters. The collection also included 350-400 daguerreotypes, among them images of Edwin Booth, the finest actor of his day, Stephen Douglas, Lincoln's Democratic opponent in 1860, Brigham Young, the American Mormon leader, Daniel Webster, statesman and orator, and Brady himself.

Anthony & Company put together still another huge collection of portrait negatives through an arrangement with the Brady galleries. This accumulation of from 15,000 to 18,000 negatives, still in their wooden storage boxes, and later acquired by Anthony, Scovill and Company,

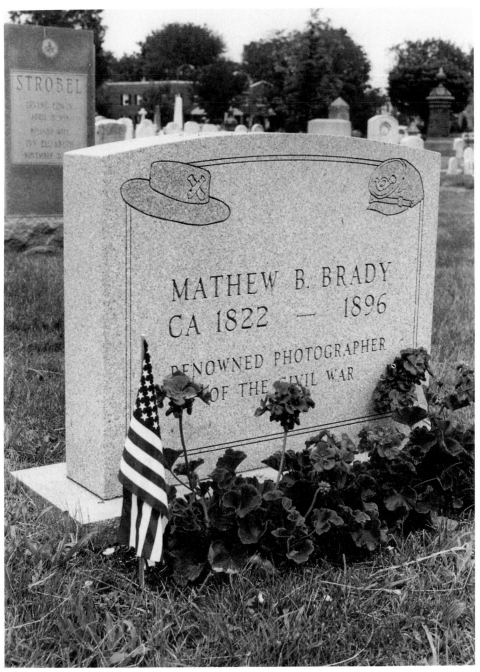

Mathew Brady is buried at the Congressional Cemetery in Washington.

was purchased in 1902 by Frederick Hill Meserve, a dedicated amateur historian and noted collector of Lincoln and Civil War images.

Meserve, who died in 1962, spent years studying and identifying the negatives. He found that many of the photographs had not actually been taken by Brady cameramen at all. They were the work of other photographers and had been copied by Brady's lab technicians and darkroom workers.

"I consider them among the most valuable in my collection," Meserve is quoted as saying in *Mathew Brady and His World*, the book written by Dorothy Meserve Kunhardt (Meserve's daughter) and Philip B. Kunhardt (Meserve's grandson) and published in 1977.

On the subject of copying, Meserve noted: "Everybody did it back then. That's how photographers added to their inventories when they couldn't photograph a subject themselves. It wasn't considered dishonest at all."

In 1981, the National Portrait Gallery, a division of the Smithsonian Institution, purchased more than 5,400 of these negatives from Meserve's heirs. The remarkable collection includes images of Abraham Lincoln and virtually every other prominent man and woman of the Civil War era.

With the acquisition of the Meserve negatives, the National Portrait Gallery joined the Library of Congress and the National Archives as a major source of original Brady material. Today, these many thousands of images are available to students and journalists, historians, and art curators—to everyone.

When filmmaker Ken Burns was producing his highly praised series, "The Civil War," first presented on television in 1990, he relied on Brady's images more than those of any other photographer. He called them "the backbone of the series," which, he said, "could not have been made without them."

So it was that Mathew Brady accomplished what he set out to ac-

complish. Before the Civil War, during it, and after it, Brady's cameras recorded the images of many hundreds of men and women of renown. By his high standards, he helped to bring excellence and esteem to the medium of photography.

In the case of the Civil War, Brady is to be praised not so much for the war photographs he took or ordered to be taken, but for his vision, for conceiving the idea of covering the war in the first place and then developing the plans to make such coverage possible.

Historian Henry Wysham Lanier, writing in *The Photographic History of the Civil War*, stated that it was Brady who "fathered the movement." Said Lanier, it was Brady's "daring and success that undoubtedly stimulated and inspired the small army of men all over the war region."

Today, Brady is rightly honored as an historian with a camera. He understood the drama and power of photographs. He gave meaning to photography; he helped to demonstrate its importance and value. Perhaps no other photographer has had so great an impact upon his profession—or the nation.

SOURCES USED IN THIS BOOK

BOOKS

Carlebach, Michael L. *The Origins of Photojournalism in America*. Washington, D.C.: Smithsonian Institution Press, 1992.

Frassanito, William A. *Antietam: The Photographic Legacy of America's Bloodiest Day*. New York: Scribner's, 1978.

Hamilton, Charles and Ostendorf, Lloyd. *Lincoln in Photographs: An Album of Every Known Pose*. Dayton, Ohio: Morningside House, 1985.

Hoobler, Dorothy and Hoobler, Thomas. *Photographing History: The Career of Mathew Brady*. New York: G.P. Putnam's, 1977.

Horan, James D. *Mathew Brady, Historian with a Camera*. New York: Crown Publishers, 1955.

Katz, D. Mark. *Witness to an Era: The Life and Photographs of Alexander Gardner*. New York: Viking Penguin, 1991.

Kunhardt, Dorothy Meserve and Kunhardt, Philip B., Jr. *Mathew Brady and His World*. Alexandria, Virginia: Time-Life Books, 1977.

McCulloch, Lou W. *Card Photographs, A Guide to Their History and Value*. Exton, Pennsylvania: Schiffer Publishing Co., 1981.

Meredith, Roy. *Mr. Lincoln's Camera Man: Mathew B. Brady*. New York: Dover Publications, 1974.

Meserve, Frederick Hill and Sandburg, Carl. *The Photographs of Abraham Lincoln*. New York: Harcourt, Brace, 1944.

Miller, Francis Trevelyn, ed. *The Photographic History of the Civil War*. 10 vols. New York: Review of Reviewers, 1912.

Ostendorf, Lloyd. *Abraham Lincoln: The Boy, the Man*. Springfield, Illinois: Philip H. Wagner, 1962.

Pfister, Harold Francis. *Facing the Light: Historic American Portrait Daguerreotypes*. Washington, D.C.: National Portrait Gallery by Smithsonian Institution Press, 1978.

Rinhart, Floyd and Rinhart, Marion. *The American Daguerreotype*. Athens, Georgia: The University of Georgia Press, 1981.

Russell, Andrew J. *Russell's Civil War Photographs*. New York: Dover Publications, 1982.

Sandweiss, Martha A., ed. *Photography in Nineteenth-Century America*. Fort Worth, Texas: Amon Carter Museum, 1991.

Taft, Robert. *Photography and the American Scene: A Social History, 1839–1889*. New York: The Macmillan Company, 1938.

Trachtenberg, Alan. *Reading American Photographs*. New York: Hill and Wang, 1989.

Welling, William. *Photography in America: The Formative Years, 1839–1900*. Albuquerque, New Mexico: University of New Mexico Press, 1978.

MAGAZINE ARTICLES AND OTHER SOURCES

"Brady's New Photographic Gallery." *Frank Leslie's Illustrated Newspaper*, January 5, 1861.

Catalogue of Card Photographs, Published and Sold by E. & H.T. Anthony (facsimile edition), New York, November, 1862.

Cobb, Josephine. "Mathew B. Brady's Photographic Gallery in Washington." *Records of the Columbia Historical Society*, New York (1953–56).

Gallery of Illustrious Americans. "Containing the Portraits and Biographical Sketches of Twenty-Four of the Most Eminent Citizens of the Republic

since the Death of Washington." C. Edwards Lester, ed. New York: D'Avignon Press, 1951.

James, Theodore, Jr. "Tom Thumb's Giant Wedding," *Smithsonian*, September, 1973.

Kelbaugh, Ross J. "Introduction to Civil War Photography," Thomas Publications, Gettysburg, Pennsylvania, 1991.

Kunhardt, Philip B., Jr. "Hold Still—Don't Move a Muscle: You're on Brady's Camera!," *Smithsonian*, August, 1977.

Kunhardt, Philip B., Jr. "Images of Which History Was Made Bore the Mathew Brady Label," *Smithsonian*, July, 1977.

Munson, Douglas. "The Process of Making a Civil War Photograph." *Incidents of the War*, Vol. 2, No. 2, Summer, 1987.

Townsend, George A., "Brady, the Grand Old Man of American Photography." New York *World*, April 12, 1861.

Zinkham, Helena. "Pungent Salt: Mathew Brady's 1866 Negotiations with the New York Historical Society." *History of Photography*, January-March, 1986.

INDEX

Page references in italics indicate photographs or other illustrative material.

FOSSIL RIDGE PUBLIC LIBRARY DISTRICT
Braidwood, IL 60408